Cool Restaurants Dubai

teNeues

Imprint

Editors: Sabina Marreiros, Martin Nicholas Kunz

Editorial coordination: Hanna Martin

Photos (location): Courtesy Al Bustan Rotana Hotel (Come Prima, Rodeo Grill), Markus Bachmann (Amwaj, Cascades, Dunes Café, The Exchange Grill, Al Forsan, Al Hadheerah, Hoi An, Jambase, The Junction, Al Mahara, Manhattan Grill, Marrakech, Miyako, The Noodle House, Pisces, Rib Room, Shang Palace, Shoo Fee Maa Fee, Tokyo@the Towers, Vu's, Zheng He's), Courtesy Park Hyatt (Traiteur), Martin Nicolas Kunz (Nina, Pierchic, Segreto)

Introduction: Heinfried Tacke

Layout & Pre-press: Kerstin Graf, Jan Hausberg, Martin Herterich

Imaging: Jan Hausberg

Translations: Dr. Suzanne Kirkbright / Artes Translations
Conan Kirkpatrick (English), Brigitte Villaumié (French), Carmen de Miguel (Spanish), Maria Letizia Haas (Italian), Nina Hausberg (German, English / recipes)

Produced by fusion publishing GmbH, Stuttgart . Los Angeles www.fusion-publishing.com

Published by teNeues Publishing Group

teNeues Verlag GmbH + Co. KG
Am Selder 37
47906 Kempen, Germany
Tel.: 0049-2152-916-0
Fax: 0049-2152-916-111
Press department:
arehn@teneues.de
Phone: 0049-2152-916-202

teNeues
International Sales Division
Speditionstraße 17
40221 Düsseldorf, Germany
Tel.: 0049-211-994597-0
Fax: 0049-211-994597-40
E-mail: books@teneues.de

teNeues Publishing Company
16 West 22nd Street
New York, NY 10010, USA
Tel.: 001-212-627-9090
Fax: 001-212-627-9511

teNeues Publishing UK Ltd.
P.O. Box 402
West Byfleet
KT14 7ZF, Great Britain
Tel.: 0044-1932-403509
Fax: 0044-1932-403514

teNeues France S.A.R.L.
4, rue de Valence
75005 Paris, France
Tel.: 0033-1-55766205
Fax: 0033-1-55766419

teNeues Ibérica S.L.
Pso. Juan de la Encina 2–48
Urb. Club de Campo
28700 S.S.R.R. Madrid, Spain
Tel.: 0034-657-132133
Tel./Fax: 0034-91-6595876

www.teneues.com

ISBN-10: 3-8327-9149-3
ISBN-13: 978-3-8327-9149-0

Average price reflects the average cost for a dinner main course, menu price for a multiple course menu. All prices exclude beverages. Recipes serve four.

Contents	Page

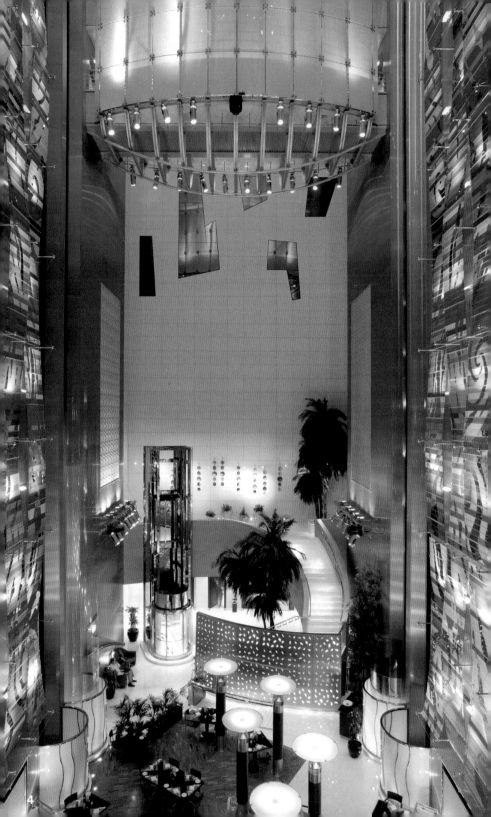

Introduction

Hospitality in the Arab world is generally regarded as proverbial. However, few of us would immediately think of restaurants and associate the word "cool" with them. Rather, images jump to mind that are dominated by folklore: Generous hosts with long robes filling small, round, finely chiseled tables in modest huts. Quite a romantic picture, without a doubt, but also a picture that a city like Dubai hardly does justice to anymore. The erstwhile city of Bedouins has evolved into a cosmopolitan metropolis. As the gate to the Near and Far East, this port city is one of the hubs of global trade. All major banks are represented here. Gigantic building projects bear witness to the prosperity of the city. The artificial island called The Palm or the seven-star destination Burj Al Arab have half the world talking. In 2007 the largest airport in the world is scheduled to open. The list of superlatives seems endless.

Indeed, the city is like a magnet. 90 percent of its residents come from other countries, including more than 50 000 millionaires. These opulent guests are always on the lookout for one-of-a-kind places. It is also what characterizes the restaurant scene of Dubai. Whoever pays a visit to it will discover more than just a pearl of the night.

Whether it's a seafood restaurant with underwater animation entirely in a class of its own or a nightlife address on the 50th floor of the Emirates Tower—with their luxurious style and their inclination towards extravagance, the restaurants gathered here give an idea of how cool and chic are defined at this boundary between the Orient and the Occident. Professionals in the business can gather worthwhile insights here. Meanwhile, globetrotters among the readers yearning to see the world are invited to come along on an amply illustrated excursion. Because what makes Dubai such a fascinating place is the fact that this is where architects and designers turn their visions of the future into reality. That said, we hope you enjoy exploring a world of tomorrow.

Heinfried Tacke

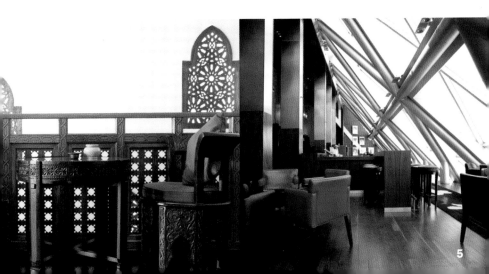

Einleitung

Die Gastfreundschaft in der arabischen Welt gilt weithin als sprichwörtlich. Doch nur wenige würden auf Anhieb an Restaurants denken, zu denen einem spontan das Attribut „cool" einfällt. Stattdessen drängen sich Bilder auf, die vor allem von Folklore bestimmt sind: Gastgeber in langen Gewändern, die in bescheidener Hütte großzügig die kleinen runden, fein ziselierten Tischchen füllen. Zweifellos ein recht romantisches Bild, das eine Stadt wie Dubai kaum mehr zu bedienen weiß. Die einstige Beduinenstadt hat sich zu einer weltläufigen Metropole entwickelt. Als Tor zum Nahen und Fernen Osten zählt die Hafenstadt zu den zentralen Umschlagplätzen für den globalen Handel. Alle großen Banken zeigen hier Präsenz. Sichtbare Zeichen für den Boom in der Stadt sind gewaltige Bauprojekte. Von der künstlichen Insel The Palm oder der Sieben-Sterne-Destination Burj Al Arab spricht die halbe Welt. 2007 folgt die Inbetriebnahme des größten Airports der Welt. Und derlei Superlative nehmen kein Ende.
So wirkt die Stadt wie ein Magnet. 90 Prozent der Einwohner stammen aus anderen Ländern, unter ihnen über 50 000 Millionäre. Diese betuchten Gäste befinden sich immerzu auf der Suche nach Orten mit dem gewissen Extra. Dies prägt nicht zuletzt die Restaurantszene Dubais. Wer sich darin tummelt, stößt auf mehr als nur eine Perle der Nacht.
Ob als Fischrestaurant mit einer Unterwasseranimation, die ihresgleichen sucht, oder als Nightlife-Adresse im 50. Stock der Emirates Towers – mit dem gehobenen Stil und Hang zum Außergewöhnlichen geben die hier versammelten Restaurants einen Eindruck davon, was man an der Nahtstelle von Orient und Okzident unter cool und chic versteht. Dem Profi der Branche erlaubt die Übersicht nützliche Einblicke. Der welthungrige Globetrotter unter den Lesern wird derweil auf eine bilderreiche Exkursion mitgenommen. Denn der besondere Reiz von Dubai besteht darin, dass hier Bauherren wie Designer ihre Visionen von der Zukunft real werden lassen. Insofern: Viel Spaß beim Schmökern in einer Welt von morgen.

Heinfried Tacke

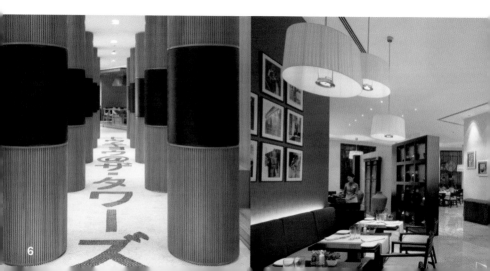

Introduction

L'hospitalité du monde arabe est proverbiale tout autour de la terre. Bien peu cependant auraient spontanément l'idée de restaurants auxquels on pourrait aller jusqu'à attribuer le qualificatif de « cool ». À sa place, ce sont des images imprégnées avant tout de folklore qui viennent à l'esprit : des hôtes en longues robes qui, dans une modeste hutte, remplissent généreusement les petites tables basses, rondes, finement ciselées.

Un tableau incontestablement très romantique auquel une ville comme Dubaï ne correspond pratiquement plus. La ville de bédouins de jadis s'est transformée en une métropole de rang international. Cette ville portuaire, porte du Proche et de l'Extrême Orient, fait partie des plates-formes de transbordement essentielles dans le commerce global. Toutes les grandes banques y affichent leur présence. D'énormes projets de construction sont les signes évidents de la croissance de la ville. La moitié de la planète parle de l'île artificielle The Palm ou de Burj Al Arab, la destination à sept étoiles. En 2007, c'est le plus grand aéroport du monde qui sera mis en service. La liste de tels superlatifs est infinie.

Aussi la ville fait-elle l'effet d'un aimant. 90 pourcent des habitants sont originaires d'autres pays ; parmi eux se trouvent plus de 50 000 millionnaires. Ces hôtes aisés sont perpétuellement à la recherche d'endroits avec le je-ne-sais-quoi de plus. Ce qui influe aussi sur la scène des restaurants de Dubaï. Celui qui en fait la tournée découvre bien plus qu'une simple perle de la nuit.

Qu'il s'agisse d'un restaurant de poissons avec une animation sous-marine qui offre des opportunités inégalées, ou d'une adresse de noctambule au 50ème étage des Emirates Towers – avec un style raffiné et une tendance à l'exceptionnel –, les restaurants sélectionnés ici donnent une impression de ce que l'on entend par cool et chic à la frontière entre l'Orient et l'Occident. Cette vue d'ensemble permet au professionnel de la branche d'y jeter un coup d'œil utile. Quant au globe-trotter assoiffé de connaissances du monde parmi les lecteurs, il est emporté dans une excursion en images. Car l'attrait principal de Dubaï réside dans le fait qu'ici, les maîtres d'ouvrage comme les designers réalisent leurs visions du futur. Passez donc de bons moments à la lecture du monde de demain.

Heinfried Tacke

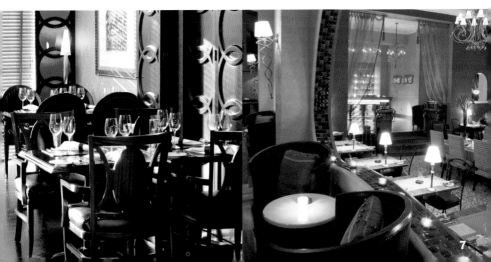

Introducción

La hospitalidad del mundo árabe continúa siendo proverbial. Sin embargo, en un primer momento, a pocos les vendrían a la mente restaurantes a los que atreverse a denominar "cool". Al contrario, las imágenes típicas están cargadas de carácter folclórico: Anfitriones con largas túnicas en cabañas austeras repletas de mesitas redondas de lacería.

Sin duda un cuadro romántico que una ciudad como Dubai ya no sabe mantener. Lo que en su día fue un poblado beduino se ha convertido en una metrópoli internacional. La ciudad portuaria es puerta de acceso al lejano oriente, al oriente próximo y uno de los enclaves centrales de trasbordo para el comercio global. Aquí todos los grandes bancos están presentes. Efecto visible de este estallido son los impresionantes proyectos arquitectónicos; medio mundo habla de la isla artificial The Palm o del hotel de siete estrellas Burj Al Arab. En 2007 se pondrá en funcionamiento del aeropuerto más grande del mundo. La serie de superlativos es interminable.

De ahí que la ciudad atraiga como un imán. El 90 por ciento de sus habitantes, entre los que figuran 50 000 millonarios, provienen de otros países. Esta clientela adinerada se agita en la búsqueda continua de lugares con ese toque especial. Y los restaurantes de Dubai se caracterizan por ello. Quien se mueva en estos ambientes se topará con algo más que una perla en la noche.

Ya sea como restaurante de pescado único con animación bajo el agua, o como dirección ideal para vivir la noche en el piso 50 de Emirates Towers, con su estilo elegante y de gusto por lo atípico, los restaurantes aquí reunidos dan una impresión de lo que se entiende por cool y sofisticado en este punto de encuentro entre Oriente y Occidente. Al profesional del ramo se le proporcionan una serie de miradas prácticas; al viajero hambriento una excursión cargada de imágenes. Y es que el encanto especial de Dubai reside en que aquí tanto constructores como diseñadores hacen realidad sus visiones futuristas. Con ello, ¡que disfrute degustando en el mundo de mañana!

Heinfried Tacke

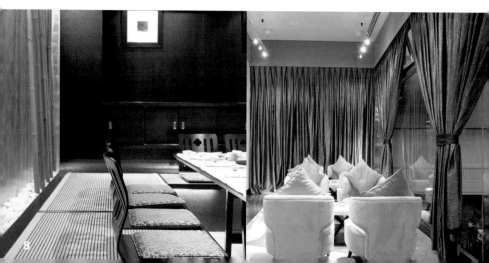

Introduzione

L'ospitalità araba è proverbiale. Pochi, tuttavia, penserebbero d'impulso a ristoranti che potrebbero essere definiti addirittura "cool". Vengono piuttosto in mente immagini dal sapore prettamente folkloristico: gente ospitale vestita di lunghe tuniche, intenta a imbandire, all'interno di modeste capanne, bassi tavoli rotondi e finemente cesellati.

Si tratta senza dubbio di un'immagine assai romantica ormai inconsueta in un luogo come Dubai, che da città beduina si è evoluta in metropoli di livello internazionale. Porta di accesso al Vicino ed Estremo Oriente, questa città portuale è uno dei posti di trasbordo cardine del commercio globale. Tutte le banche più importanti vi sono rappresentate. Gli imponenti progetti edili sono un segno visibile dell'eccezionale sviluppo urbano: l'isola artificiale The Palm o l'hotel a sette stelle Burj Al Arab sono sulla bocca di mezzo mondo. Nel 2007 seguirà la messa in esercizio del più grande aeroporto del mondo. E non c'è fine a superlativi di questo genere.

L'effetto è magnetico: il 90 per cento degli abitanti proviene da paesi stranieri, più di 50 000 sono milionari alla perpetua ricerca di luoghi che abbiano quel qualcosa in più. Questo aspetto contraddistingue anche la scena gastronomica di Dubai: chi la frequenta, incontrerà ben più di una perla della notte.

Che si tratti di un locale con specialità a base di pesce, in cui pulluli un fantasmagorico mondo sottomarino, o di un ritrovo notturno al 50esimo piano delle Emirates Towers, i ristoranti che vi proponiamo, dallo stile raffinato e dal tocco esclusivo, rendono l'idea di ciò che si intende per cool e chic qui, nel punto in cui Oriente e Occidente si incontrano. Il prospetto sarà utile ai già esperti, mentre la curiosità del globetrotter sarà soddisfatta da una ricca carrellata di illustrazioni. Il fascino particolare di Dubai consiste nel fatto che, in questo luogo, sia i costruttori sia i designer hanno la possibilità di realizzare le proprie visioni del futuro. Buona lettura, quindi, a chi si appresta a sfogliare questo libro, tra le cui pagine si intravede il mondo di domani.

Heinfried Tacke

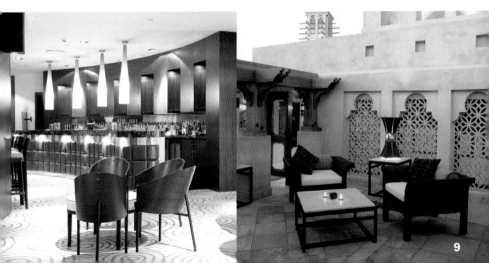

Amwaj

Design: LWDesign Group LLC | Owner: Obeid Al Jaber
Chef: Matthias Diether

Shangri-La Hotel, Dubai, Sheikh Zayed Road | Dubai
Phone: +971 4 343 8888
www.shangri-la.com
Opening hours: Sun–Fri lunch noon to 3 pm, dinner 7 pm to midnight, closed on Sat
Menu price: AED 95
Cuisine: Seafood, Euro-fusion
Special features: Oyster bar

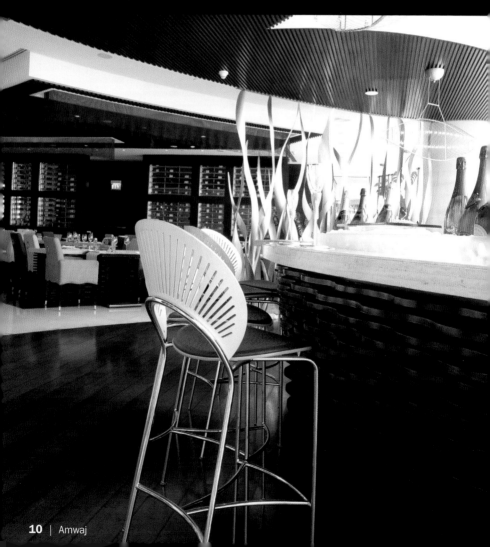

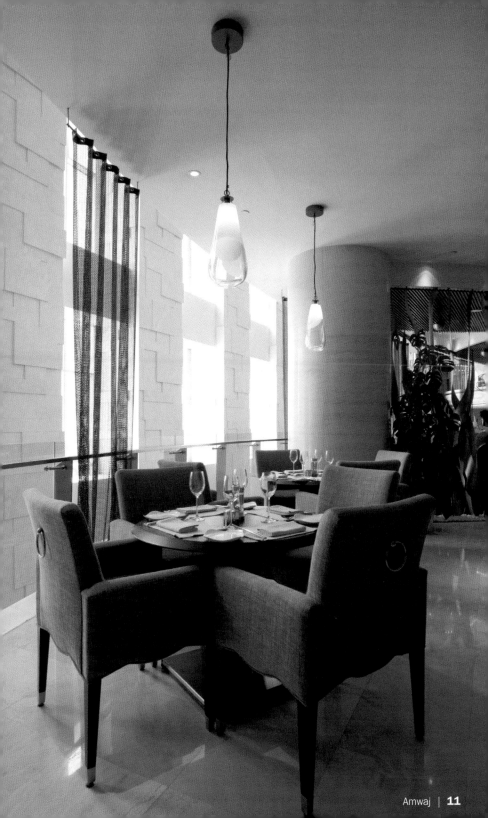

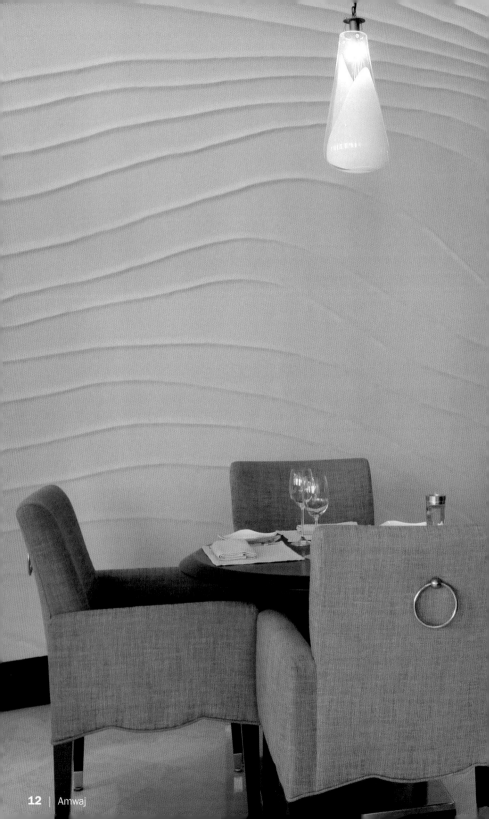

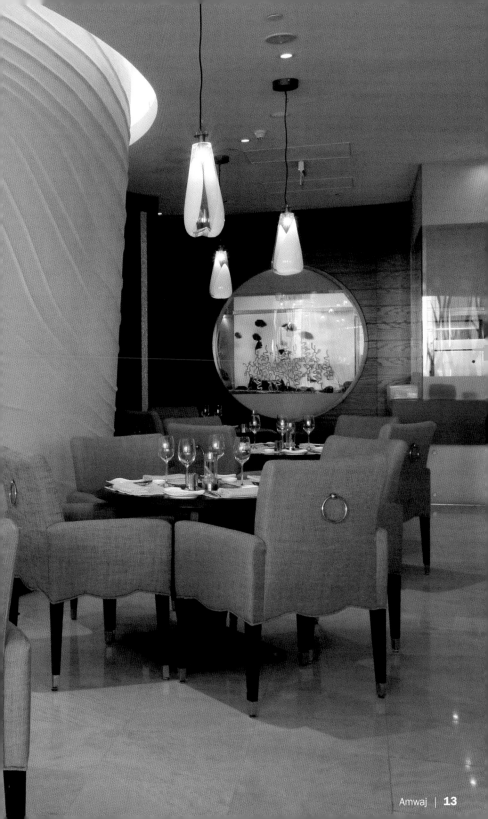

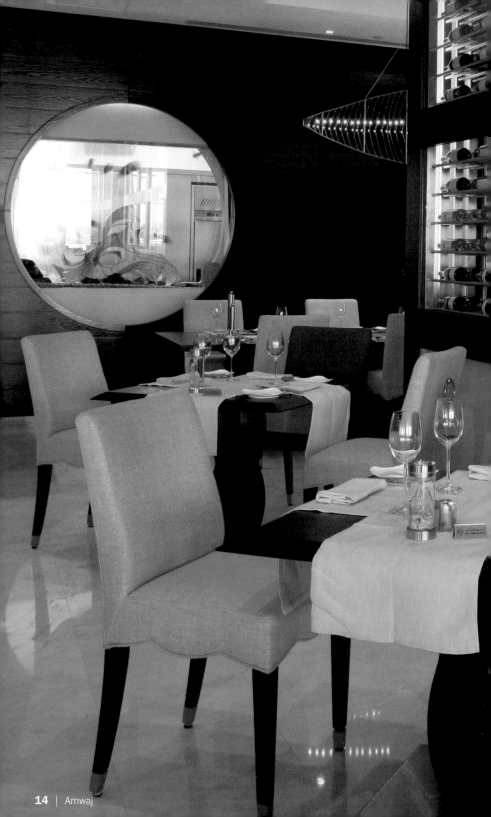

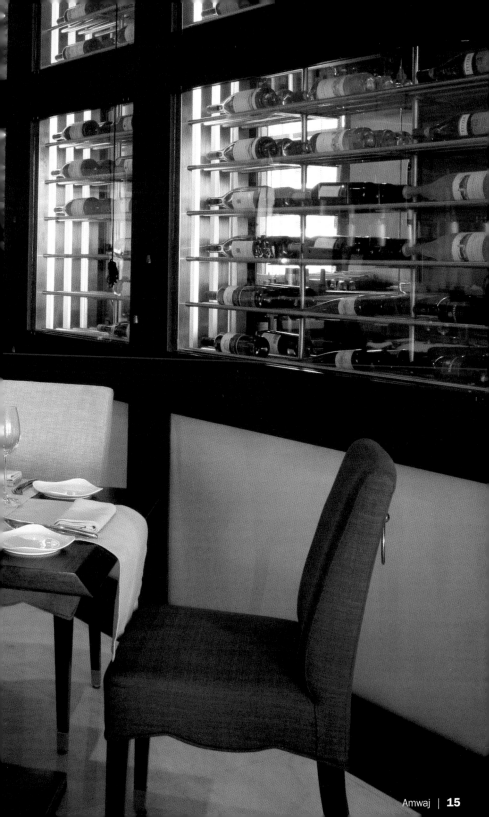

Artichoke and Bell Pepper Tarte

Artischocken-Paprika-Tarte
Tarte à l'artichaut et au poivron
Tartaleta de alcachofas y pimiento
Tarte di carciofi e peperoni

8 marinated artichoke hearts, cut in 8 pieces
5 1/2 oz young spinach
6 oz goat cheese
4 small new potatoes, sliced
2 tbsp butter
2 pickled grilled bell pepper, sliced
6 1/2 oz puff pastry
1 egg yolk
Salt, pepper
Vegetable straw, vinegar and oil for garnish

Sear the potato slices in butter, season and layer with the artichokes, spinach, goat cheese and bell pepper in four circular baking dishes. Cut out the pastry in the same size, brush with egg yolk and place with the egg yolk side up on top of the vegetables. Bake at 430 °F in a preheated oven for approx. 10–15 minutes, until the puff pastry is golden brown.

To serve turn the baking dishes upsidedown onto the plates, carefully lift off the baking dishes and garnish with vegetable straw, vinegar, oil and pepper if desired.

8 marinierte Artischockenherzen, geachtelt
160 g junger Spinat
180 g Ziegenkäse
4 kleine neue Kartoffeln, in Scheiben
2 EL Butter
2 eingelegte gegrillte Paprika, in Scheiben
200 g Blätterteig
1 Eigelb
Salz, Pfeffer
Gemüsestroh, Essig und Öl zum Anrichten

Die Kartoffelscheiben in der Butter anbraten, würzen und mit den Artischocken, dem Spinat, dem Ziegenkäse und der Paprika in vier runde Auflaufformen schichten. Den Blätterteig in der gleichen Größe ausstechen, mit Eigelb einpinseln und mit der Eigelbseite nach oben auf das Gemüse legen. Bei 220 °C im vorgeheizten Ofen ca. 10–15 Minuten backen, bis der Blätterteig goldbraun geworden ist.

Zum Servieren die Förmchen auf Teller stürzen, vorsichtig die Form abheben und evtl. mit Gemüsestroh, Essig, Öl und Pfeffer anrichten.

8 cœurs d'artichaut marinés, coupés en huit
160 g de jeunes épinards
180 g de fromage de chèvre
4 petites pommes de terre nouvelles en tranches
2 c. à soupe de beurre
2 poivrons grillés en conserve, en tranches
200 g de pâte feuilletée
1 jaune d'œuf
Sel, poivre
Foin de légumes, vinaigre et huile pour la présentation

Faire revenir les tranches de pomme de terre dans le beurre, assaisonner et empiler dans quatre moules à gratin ronds avec les artichauts, les épinards, le fromage de chèvre et le poivron. Découper la pâte feuilletée à la dimension des moules, la badigeonner de jaune d'œuf et la déposer sur les légumes, côté badigeonné vers le haut. Faire cuire dans le four préchauffé à 220 °C pendant env. 10–15 minutes, jusqu'à ce que la pâte feuilletée soit bien dorée.

Pour servir, renverser les moules sur les assiettes, démouler prudemment et dresser éventuellement avec du foin de légumes, du vinaigre, de l'huile et du poivre.

8 corazones de alcachofas marinadas cortados en 8 trozos
160 g de espinaca joven
180 g de queso de cabra
4 patatas nuevas en rodajas
2 cucharadas de mantequilla
2 pimientos asados marinados en rodajas
200 g de masa de hojaldre
1 yema de huevo
Sal, pimienta
Verdura troceada, aceite y vinagre para decorar

Saltear las rodajas de patata en mantequilla, sazonarlas y en cuatro moldes de horno redondos colocarlas en capas con las alcachofas, las espinacas, el queso de cabra y el pimiento. Cortar la masa de hojaldre del mismo tamaño, untarla con la yema de huevo y colocarla sobre la verdura con la cara untada de huevo hacia arriba. Hacer al horno previamente calentado a 220 °C durante 10–15 minutos aprox. hasta que la masa esté dorada.

Para servir, volcar los moldes en platos, levantarlos con cuidado y si es necesario sazonar con aceite, vinagre y pimienta y decorar con verdura.

8 cuori di carciofo marinati e tagliati in otto parti
160 g di spinaci giovani
180 g di formaggio di capra
4 piccole patate novelle tagliate a fette
2 cucchiai di burro
2 peperoni sott'aceto alla griglia tagliati a fette
200 g di pasta sfoglia
1 tuorlo d'uovo
Sale, pepe
Un ciuffo di verdure, aceto e olio per la guarnizione

Rosolare nel burro le fette di patate, condirle e disporle a strati in quattro stampi rotondi insieme con i carciofi, gli spinaci, il formaggio e i peperoni. Ritagliare la pasta sfoglia nella stessa misura degli stampini, spennellarla con il tuorlo d'uovo e disporla sulle verdure, volgendo verso l'alto il lato spennellato. Cuocere in forno riscaldato a 220 °C per circa 10–15 minuti, finché la sfoglia non sarà dorata.

Al momento di servire, porre gli stampini sui piatti ed estrarli delicatamente. Eventualmente, guarnire con un ciuffo di verdure, aceto, olio e pepe.

Cascades

Design: Decorpoint | Owner: The Fairmont Dubai
Chef: Nathan Brown

The Fairmont Dubai, Sheikh Zayed Road | Dubai
Phone: +971 4 311 8316
www.fairmont.com
Opening hours: Open 24 hours
Menu price: AED 110
Cuisine: Mediterranean with touches of local flavors

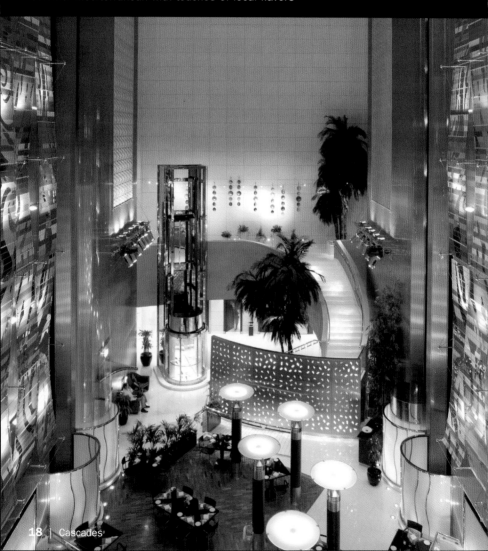

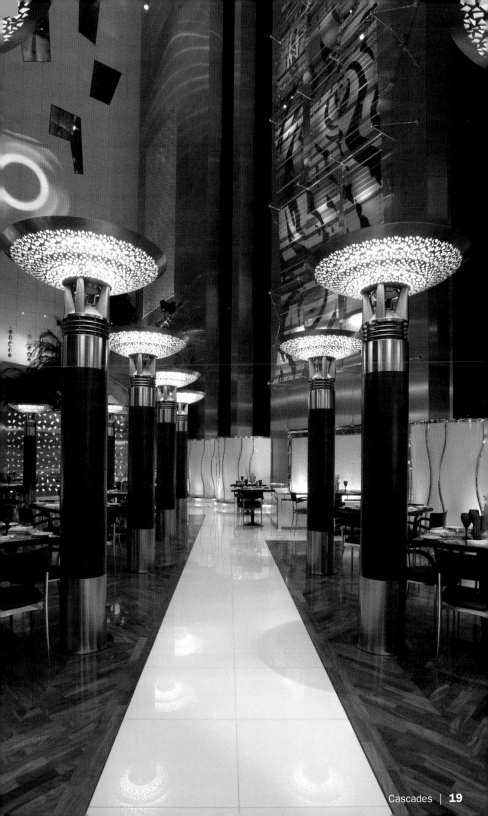

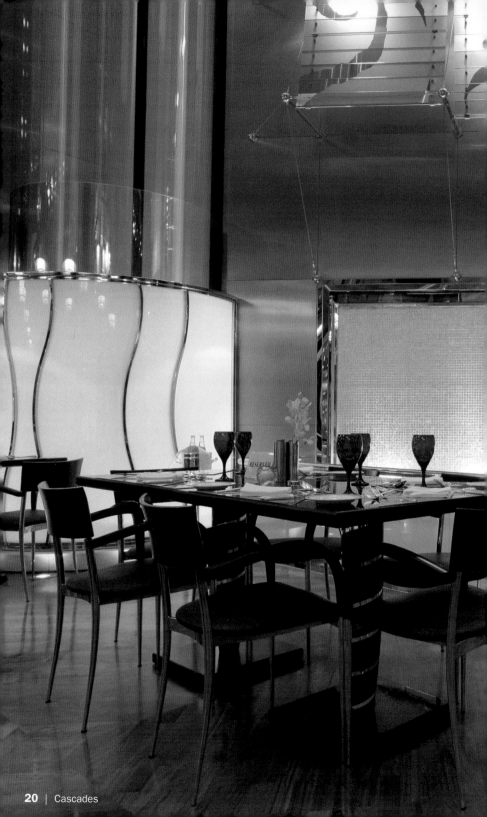

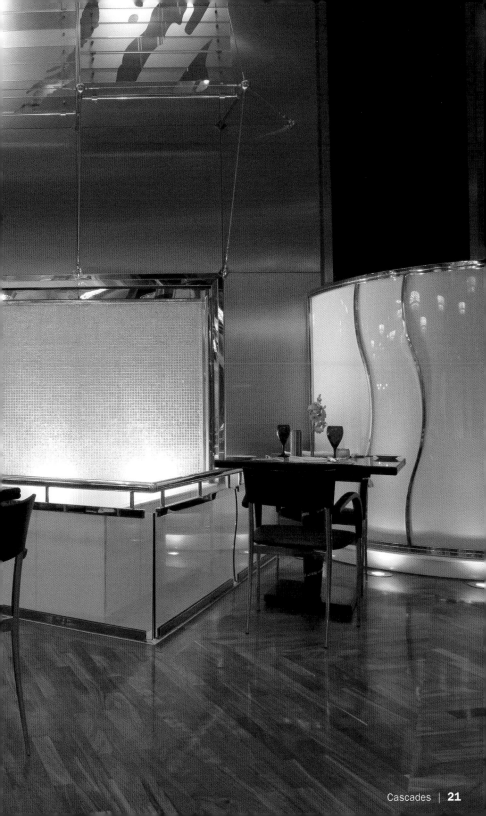

Seared Red Mullet
with Warm Fennel Salad

Gebratene Meerbarbe mit warmem
Fenchelsalat

Rouget grillé à la salade de fenouil
chaude

Salmonete de roca frito con ensalada
caliente de hinojo

Triglie arrostite con insalata calda di
finocchi

8 red mullet fillets, cleaned and with skin
7 tbsp olive oil
2 fennel, in thin slices
Juice of 1 lemon
1 tsp mustard
4 oz green beans, cleaned
2 tbsp butter
4 tbsp black olive tapenade (glass)
2 tbsp each green and yellow zucchini, red chili,
capers, red onion, cellery and eggplant, in small
cubes
Salt, pepper
Cress for garnish

Sauté the fennel in 2 tbsp olive oil, deglaze
with lemon juice, add the mustard and season.
Keep warm.
Blanch the beans and set aside. Sear the diced
vegetables in 2 tbsp olive oil, season with salt,
let the liquid evaporate, season and set aside.
Season the fish fillets from both sides, sear in
3 tbsp olive oil for 2 minutes from the skin side
only and keep warm. Let rest for 5 minutes. Toss
the blanched beans in butter and season. Divide
the fennel salad amongst four plates, drizzle with
a little vinaigrette and olive tapenade and place
2 fish fillets on each plate. Place the beans as a
bunch on top of the fish, spoon 1 tbsp vegetable
stew over it and garnish with cress.

8 Meerbarbenfilets, gesäubert und mit Haut
7 EL Olivenöl
2 Fenchelknollen, in dünnen Scheiben
Saft von 1 Zitrone
1 TL Senf
120 g grüne Bohnen, geputzt
2 EL Butter
4 EL schwarze Ol014ventapenade (Glas)
Je 2 EL grüne und gelbe Zucchini, rote Chili,
Kapern, rote Zwiebeln, Staudensellerie und
Aubergine, in kleinen Würfeln
Salz, Pfeffer
Kresse zum Garnieren

Den Fenchel in 2 EL Olivenöl anschwitzen, mit
Zitronensaft ablöschen, den Senf zugeben und
würzen. Warm stellen.
Die Bohnen blanchieren und beiseite stellen.
Das gewürfelte Gemüse in 2 EL Olivenöl anbra-
ten, salzen, Wasser ziehen lassen und die
Flüssigkeit einkochen lassen, abschmecken und
beiseite stellen.
Den Fisch von beiden Seiten würzen, in 3 EL
Olivenöl nur auf der Hautseite für 2 Minuten
scharf anbraten und warm stellen. Ca. 5 Minuten
ruhen lassen. Die blanchierten Bohnen in Butter
schwenken und würzen. Den Fenchelsalat auf
vier Tellern verteilen, mit etwas Salatdressing und
Oliventapenade beträufeln und jeweils 2 Fischfilets
auf den Salat setzen. Die Bohnen als Bündel auf
den Fisch setzen, jeweils 1 EL Gemüseragout da-
raufgeben und mit Kresse garnieren.

8 filets de rouget, nettoyés, avec la peau
7 c. à soupe d'huile d'olive
2 bulbes de fenouil émincés
Le jus d'1 citron
1 c. à café de moutarde
120 g de haricots verts nettoyés
2 c. à soupe de beurre
4 c. à soupe de tapenade d'olives noires (en pot)
Respectivement 2 c. à soupe de courgette verte
et jaune, piment rouge, câpres, oignon rouge,
céleri branche et aubergine, en petits dés
Sel, poivre
Cresson pour la garniture

Faire suer le fenouil dans 2 c. à soupe d'huile
d'olive, mouiller avec le jus de citron, ajouter
la moutarde et assaisonner. Garder au chaud.
Blanchir les haricots et réserver.
Faire sauter les légumes en dés dans 2 c. à
soupe d'huile d'olive, saler, laisser les rendre leur
eau et cuire jusqu'à évaporation, assaisonner et
réserver.
Assaisonner le poisson des deux côtés, le saisir
à feu vif 2 minutes, dans 3 c. à soupe d'huile
d'olive, du côté peau seulement et garder au
chaud. Laisser reposer env. 5 minutes. Poêler les
haricots blanchis dans le beurre et assaisonner.
Répartir la salade de fenouil sur quatre assiettes,
arroser de vinaigrette et de tapenade d'olives et
déposer respectivement 2 filets sur la salade.
Disposer les haricots en bottes sur le poisson,
ajouter 1 c. à soupe de ragoût de légumes et
garnir de cresson.

8 filetes de salmonete de roca limpios y con piel
7 cucharadas de aceite de oliva
2 bulbos de hinojo en rodajas finas
Zumo de 1 limón
1 cucharadita de mostaza
120 g de judías verdes limpias
2 cucharadas de mantequilla
4 cucharadas de crema de aceitunas negras
(tapenade en bote)
2 cucharadas respectivamente de calabacín
verde y amarillo, chiles rojos, alcaparras, cebo-
llas rojas, apio y berenjenas cortados en dados
Sal, pimienta
Berros para decorar

Rehogar el hinojo en 2 cucharadas de aceite de
oliva, rociarlo con zumo de limón, añadir la mos-
taza y sazonarlo. Reservar en caliente.
Blanquear las judías y reservarlas. Rehogar la
verdura picada en 2 cucharadas de aceite de
oliva, salarla, dejar que suelte el agua y cocer el
líquido. Sazonarla y reservarla.
Salpimentar el pescado por ambos lados, freírlo
en 3 cucharadas de aceite de oliva a fuego
fuerte durante 2 minutos sólo por el lado de la
piel. Dejarlo reposar 5 minutos aprox. Rehogar
en mantequilla las verduras blanqueadas y sazo-
narlas. Distribuir la ensalada de hinojo en cuatro
platos, rociarla con un poco de aliño y crema de
aceitunas y disponer 2 filetes de pescado en
cada plato. Colocar un ramillete de judías sobre
el pescado, añadir 1 cucharada de la verdura
rehogada y decorar con berros.

8 filetti di triglia puliti e con la pelle
7 cucchiai di olio di oliva
2 teste di finocchio tagliate a fette sottili
Il succo di 1 limone
1 cucchiaino di senape
120 g di fagiolini verdi puliti
2 cucchiai di burro
4 cucchiai di crema di olive nere (in bicchiere)
2 cucchiai rispettivamente di zucchini verdi e
gialli, peperoncino rosso, capperi, cipolle rosse,
sedano e melanzane, tutti tagliati a dadini
Sale, pepe
Crescione per la guarnizione

Rosolare il finocchio in 2 cucchiai di olio di oliva,
bagnarlo con il succo di limone, aggiungere la
senape e condire. Tenere al caldo.
Scottare i fagiolini e metterli da parte. Rosolare
le verdure a dadini in 2 cucchiai di olio di oliva,
salare, far restringere l'acqua di cottura, regolare
il condimento e tenerle da parte.
Condire il pesce da entrambi i lati, rosolarlo
a fuoco vivo per 2 minuti in 3 cucchiai di olio
di oliva solo dalla parte della pelle e tenerlo
al caldo. Lasciarlo riposare per circa 5 minuti.
Saltare nel burro i fagiolini scottati e condirli.
Ripartire in quattro piatti l'insalata di finocchi, pil-
lottarla con un po' di dressing e di crema di olive
e disporre 2 filetti di pesce su ogni porzione di
insalata. Disporre mazzetti di fagiolini sul pesce,
versare su ogni filetto 1 cucchiaio di ragout di
verdure e guarnire con il crescione.

Come Prima

Design: wa international | Owner: Al Bustan Rotana Hotel
Chef: Luca De Negri

Casablanca Road, Al Garhoud Area | Dubai
Phone: +971 4 705 4818
www.rotana.com
Opening hours: Every day lunch noon to 3 pm, dinner 7 pm to midnight, Fridays closed for lunch
Menu price: AED 150
Cuisine: Italian
Special features: Mama Mia Night every Wednesday & Friday, Come A Casa every Sunday

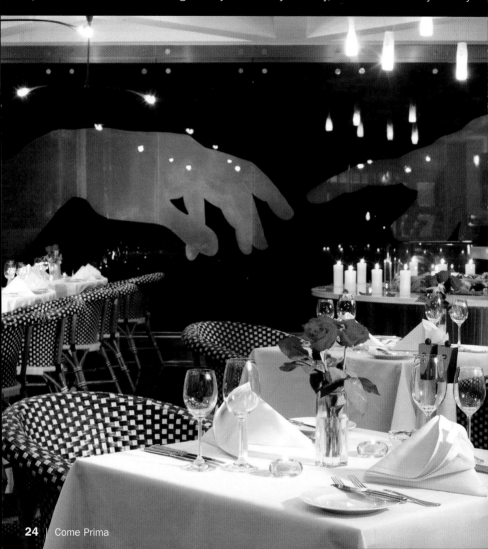

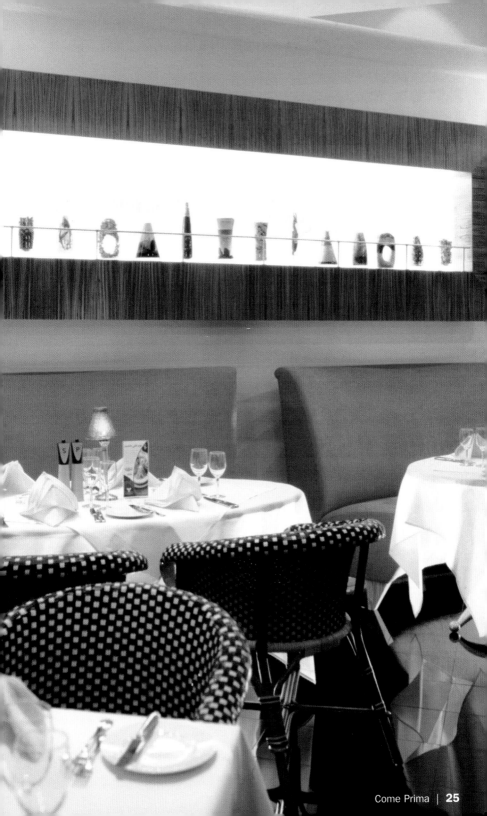

Dunes Café

Design: Wilson & Associates Inc. | Owner: Obeid Al Jaber

Shangri-La Hotel, Dubai, Sheikh Zayed Road | Dubai
Phone: +971 4 343 8888
www.shangri-la.com
Opening hours: Every day breakfast 6 am to 11 am, lunch noon to 3 pm,
dinner 7 pm to 2 am
Menu price: AED 95
Cuisine: International
Special features: Outdoor garden, terrace

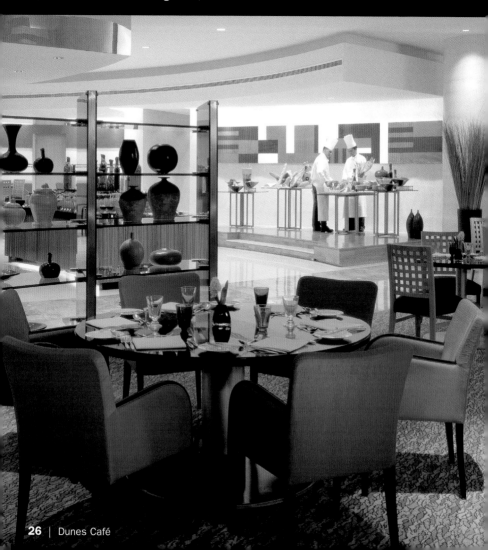

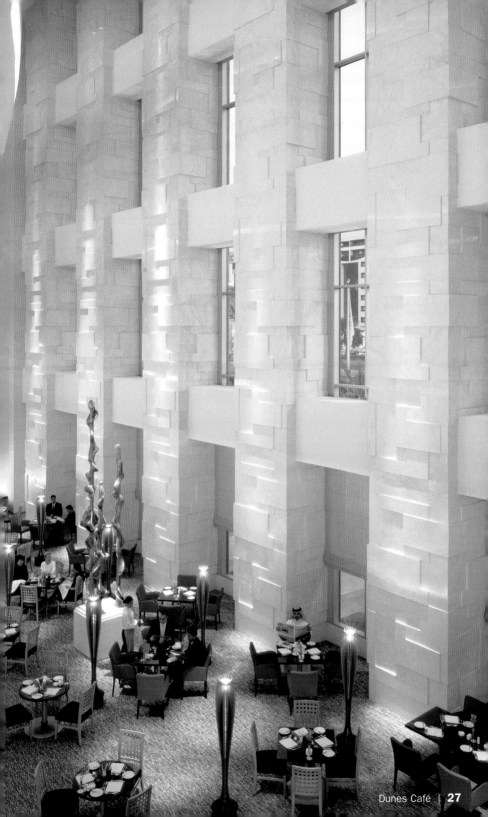

Banana-Cheesecake

with Sour Cream

Bananenkäsekuchen mit saurer Sahne

Gâteau de fromage blanc à la banane et à la crème

Pastel de plátano y queso con nata ácida

Torta al formaggio con banane e panna acida

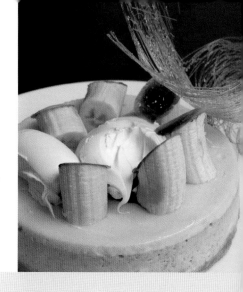

6 1/2 oz plain butter cookies, crushed
3 oz butter
2 lbs cream cheese
6 oz sugar
1 lb 4 oz mashed bananas
9 eggs
2 tsp vanilla flavoring
1 tsp banana flavoring
1 lb 1 oz sour cream
2 egg yolks, beaten
Grated zest of 1 lemon
2 bananas
Whipped cream and vanilla ice cream for decoration

Line the edge of a cake pan (diameter 10 in.) with baking parchment. Combine the cookies with the butter and press into the cake pan. Chill for 20 minutes.
Whisk the cream cheese with the sugar until smooth, add the mashed bananas and the eggs one by one and stir in 1 tsp vanilla flavoring and banana flavoring. Pour into the cake pan and bake at 290 °F for approx. 20 minutes.
In the meantime, combine the sour cream with 1 tsp vanilla flavoring and the grated lemon zest and fold under the beaten egg whites. Pour on top of the already baked cake, spread until you have a smooth surface and bake another 5–10 minutes at 290 °F.
Let the cake cool down completely, remove from the pan and garnish with banana pieces, whipped cream and vanilla ice cream.

200 g Butterkekse, zerkleinert
100 g Butter, geschmolzen
900 g Frischkäse
180 g Zucker
600 g Bananenpüree
9 Eier
2 TL Vanilleessenz
1 TL Bananenessenz
500 g saure Sahne
2 Eiweiß, steif geschlagen
Geriebene Schale von 1 Zitrone
2 Bananen
Geschlagene Sahne und Vanilleeiscreme zur Garnitur

Den Rand einer Backform (26 cm Durchmesser) mit Backpapier auslegen. Die Butterkekse mit der Butter mischen und in die Backform drücken. 20 Minuten kalt stellen.
Den Frischkäse mit dem Zucker glatt rühren, das Bananenpüree und die Eier nach und nach zugeben und 1 TL Vanille- und Bananenessenz unterrühren. In die Backform gießen und bei 140 °C ca. 20 Minuten backen.
In der Zwischenzeit die saure Sahne mit 1 TL Vanilleessenz und der geriebenen Zitronenschale mischen und das Eiweiß unterheben. Auf den bereits gebackenen Kuchen geben, glatt streichen und bei 140 °C nochmals 5–10 Minuten backen. Den Kuchen völlig auskühlen lassen, aus der Form nehmen und mit Bananenstücken, Vanilleeiscreme und geschlagener Sahne garnieren.

200 g de petits beurres, en miettes
100 g de beurre fondu
900 g de fromage frais
180 g de sucre
600 g de purée de bananes
9 œufs
2 c. à café d'essence de vanille
1 c. à café d'essence de banane
500 g de crème
2 blancs d'œuf montés en neige
Le zeste d'1 citron
2 bananes
Crème Chantilly et glace à la vanille pour la garniture

Chemiser le bord d'un moule (26 cm de diamètre) de papier sulfurisé. Mélanger les petits beurres avec le beurre et les tasser dans le moule. Mettre au frais pendant 20 minutes.
Mélanger homogènement le fromage frais et le sucre, ajouter petit à petit la purée de bananes et les œufs et incorporer 1 c. à café d'essence de vanille et d'essence de banane. Verser dans le moule et cuire à 140 °C env. 20 minutes.
Entre-temps, mélanger la crème avec 1 c. à café d'essence de vanille et le zeste de citron râpé, puis incorporer les blancs d'œuf. Déposer sur le gâteau déjà cuit, lisser et cuire au four encore 5–10 minutes à 140 °C.
Laisser refroidir complètement le gâteau, le démouler et le garnir de morceaux de bananes, de glace à la vanille et de crème chantilly.

200 g de galletas de mantequilla desmenuzadas
100 g de mantequilla derretida
900 g de queso fresco
180 g de azúcar
600 g de puré de plátano
9 huevos
2 cucharaditas de esencia de vainilla
1 cucharadita de esencia de plátano
500 g de nata ácida
2 claras de huevo a punto de nieve
Ralladura de 1 limón
2 plátanos
Nata montada y crema de helado de vainilla para decorar

Cubrir el borde de un molde de horno (de 26 cm de diámetro) con papel parafinado. Mezclar las galletas con la mantequilla y extender la masa en el molde. Reservar en lugar frío durante 20 minutos.
Mezclar bien el queso fresco con el azúcar, verter el puré de plátano y los huevos progresivamente y añadir 1 cucharadita de esencia de vainilla y plátano respectivamente. Verter la mezcla en el molde de horno y cocinarla a 140 °C durante 20 minutos aprox.
Entretanto mezclar la nata ácida con 1 cucharadita de esencia de vainilla y la ralladura de limón y añadir la clara de huevo. Añadir la mezcla al pastel ya horneado, extenderla y volver a meter en el horno a 140 °C durante unos 5–10 minutos.
Enfriar el pastel por completo, sacarlo del molde y decorarlo con trozos de plátano, crema de helado de vainilla y nata montada.

200 g di biscotti al burro sbriciolati
100 g di burro fuso
900 g di formaggio fresco
180 g di zucchero
600 g di purea di banane
9 uova
2 cucchiaini di essenza di vaniglia
1 cucchiaino di essenza di banana
500 g di panna acida
2 albumi d'uovo montati a neve
La buccia grattugiata di un limone
2 banane
Panna montata e gelato alla vaniglia per la guarnizione

Ricoprire con carta da forno il bordo di uno stampo (diametro: 26 cm). Mescolare i biscotti con il burro e pressarli nello stampo. Mettere in frigo per 20 minuti.
Mescolare il formaggio fresco con lo zucchero fino ad ottenere un composto omogeneo, incorporarvi un po' alla volta la purea di banane e le uova e unirvi 1 cucchiaino di essenza di vaniglia e 1 di essenza di banana. Versare il composto nello stampo e cuocerlo in forno a 140 °C per circa 20 minuti.
Nel frattempo, mescolare la panna acida con 1 cucchiaino di essenza di vaniglia e la buccia di limone grattugiata, quindi incorporarvi gli albumi. Stendere in modo omogeneo il composto sulla torta già cotta, quindi cuocere ancora a 140 °C per 5–10 minuti.
Lasciar raffreddare completamente la torta, estrarla dallo stampo e guarnirla con pezzetti di banana, gelato alla vaniglia e panna montata.

The Exchange Grill

Design: Paul Bishop | Owner: The Fairmont Dubai
Chef: Graham Kruse

The Fairmont Dubai, Sheikh Zayed Road | Dubai
Phone: +971 4 311 8316
www.fairmont.com
Opening hours: Every day 7 pm to midnight
Menu price: AED 275
Cuisine: Specialty grill restaurant with European flair

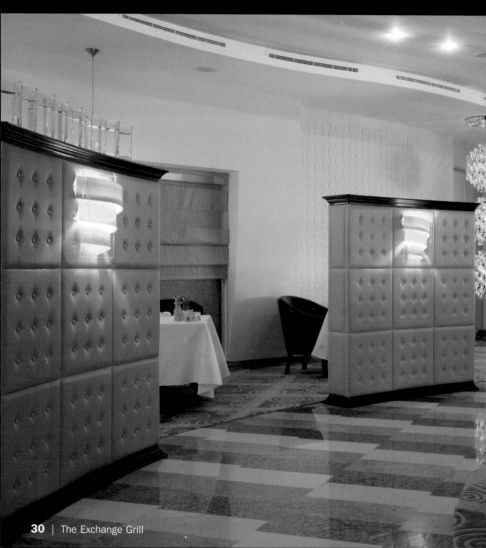

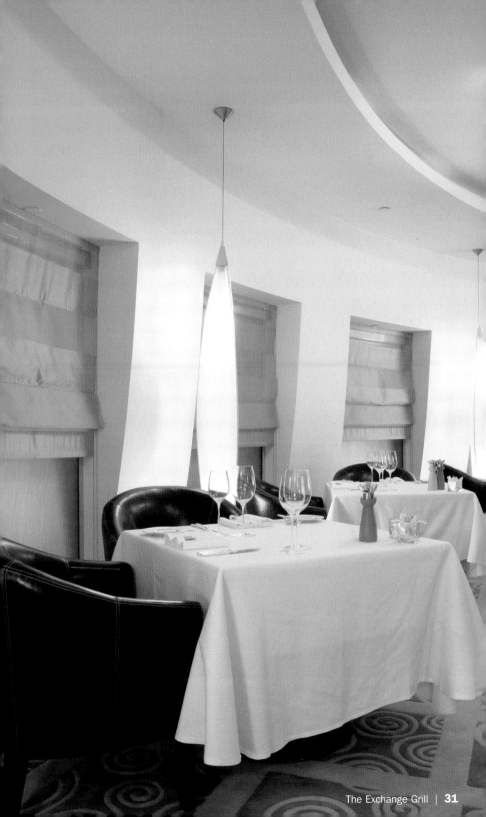

Filet Mignon
from the Wagyu-Beef

Filet Mignon vom Wagyu-Rind
Filet Mignon de bœuf wagyu
Filet Mignon de ternera Wagyu
Filetto Mignon di manzo Wagyu

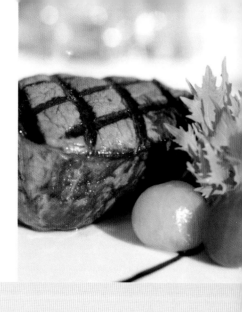

4 Wagyu-fillets, 8 oz each
Salt, pepper
4 tbsp olive oil
200 ml balsamic vinegar
Sugar
8 red and 8 yellow cherry tomatoes
3 1/2 oz young Mizuna-lettuce (Japanese lettuce)

Season the fillets with salt and pepper and rub with 2 tbsp olive oil. Place on the grill and sauté to desired tenderness.
Reduce the balsamic vinegar in a pot on top of the stove and season with sugar to take away the pungency.
Season the cherry tomatoes with salt and pepper and quickly sear in 2 tbsp olive oil from all sides until the skin bursts. Skin the tomatoes, wash the lettuce.
Garnish the plate with the reduced vinegar, place one fillet on top and arrange two red and yellow tomatoes and lettuce around it.

4 Wagyu-Filets, à 240 g
Salz, Pfeffer
4 EL Olivenöl
200 ml Balsamico-Essig
Zucker
8 rote und 8 gelbe Kirschtomaten
100 g junger Mizuna-Salat (japanischer Salat)

Die Filetstücke salzen und pfeffern und mit 2 EL Olivenöl einreiben. Auf einen Grill legen und bis zur gewünschten Garstufe grillen.
Den Balsamico-Essig in einem Topf auf dem Herd reduzieren lassen und mit Zucker abschmecken, um die Schärfe zu nehmen.
Die Kirschtomaten salzen und pfeffern und in 2 EL Olivenöl kurz von allen Seiten anbraten, bis die Schale aufplatzt. Die Tomaten enthäuten, den Salat waschen.
Mit dem reduzierten Essig den Teller garnieren, jeweils ein Stück Filet darauf legen und auf jeden Teller zwei rote und zwei gelbe Tomaten und etwas Salat anrichten.

4 filets de bœuf wagyu de 240 g chacun
Sel, poivre
4 c. à soupe d'huile d'olive
200 ml de vinaigre balsamique
Sucre
8 tomates cerises rouges et 8 jaunes
100 g de jeune salade mizuna (salade japonaise)

Saler et poivrer les filets et les badigeonner de 2 c. à soupe d'huile d'olive. Les déposer sur le grill et faire griller pour obtenir la cuisson désirée.
Dans une casserole, sur la cuisinière, faire réduire le vinaigre balsamique, rectifier l'assaisonnement avec du sucre pour enlever l'acidité.
Saler et poivrer les tomates cerises et les faire revenir rapidement de tous côtés dans 2 c. à soupe d'huile d'olive pour faire éclater la peau.
Peler les tomates puis laver la salade.
Garnir les assiettes avec la réduction de vinaigre, répartir les filets et disposer sur chaque assiette deux tomates rouges et deux tomates jaunes ainsi qu'un peu de salade.

4 filetes de Wagyu de 240 g cada uno
Sal, pimienta
4 cucharadas de aceite de oliva
200 ml de vinagre balsámico
Azúcar
8 tomates cereza rojos y 8 amarillos
100 g de joven ensalada Mizuna (lechuga japonesa)

Salpimentar los filetes y untarlos con 2 cucharadas de aceite de oliva. Hacerlos a la parrilla al punto deseado.
Reducir en una cazuela el vinagre balsámico y sazonarlo con azúcar para rebajar la acidez.
Salpimentar los tomates cereza y rehogarlos brevemente en 2 cucharadas de aceite de oliva por todos los lados hasta que la piel reviente.
Quitarles la piel y lavar la lechuga.
Decorar los platos con el vinagre reducido, disponer respectivamente un filete y colocar dos tomates rojos y dos amarillos con algo de lechuga.

4 filetti di manzo Wagyu di 240 g ciascuno
Sale, pepe
4 cucchiai di olio di oliva
200 ml di aceto balsamico
Zucchero
8 pomodorini rossi e 8 pomodorini gialli
100 g di insalata giovane Mizuna (insalata giapponese)

Salare e pepare i filetti e strofinarli con 2 cucchiai di olio di oliva. Disporli su una griglia e cuocerli fino al punto desiderato.
Lasciar restringere l'aceto balsamico a fuoco lento zuccherandolo per ridurne l'acidità.
Salare e pepare i pomodorini e rosolarli brevemente in 2 cucchiai di olio di oliva finché la pelle non si spacca. Spellare i pomodori e lavare l'insalata.
Guarnire ogni piatto con l'aceto ristretto, disporvi sopra un filetto e guarnirlo con ciuffi di insalata, due pomodori rossi e due gialli.

Al Forsan

Design: Godwin Austin Johnson | Owner: Jumeirah
Chef: Monal Malhotra

Jumeirah Bab Al Shams Desert Resort & Spa | Dubai
Phone: +971 4 809 6202
www.jumeirah.com
Opening hours: Every day breakfast 6:30 am to 10:30 am, lunch noon to 3 pm,
dinner 7 pm to 11:30 pm
Menu price: AED 150
Cuisine: International

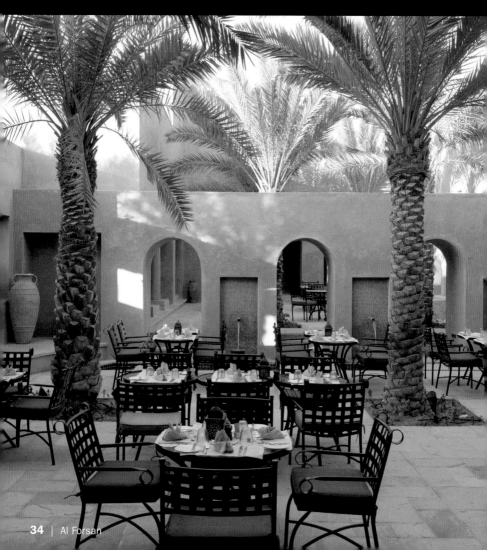

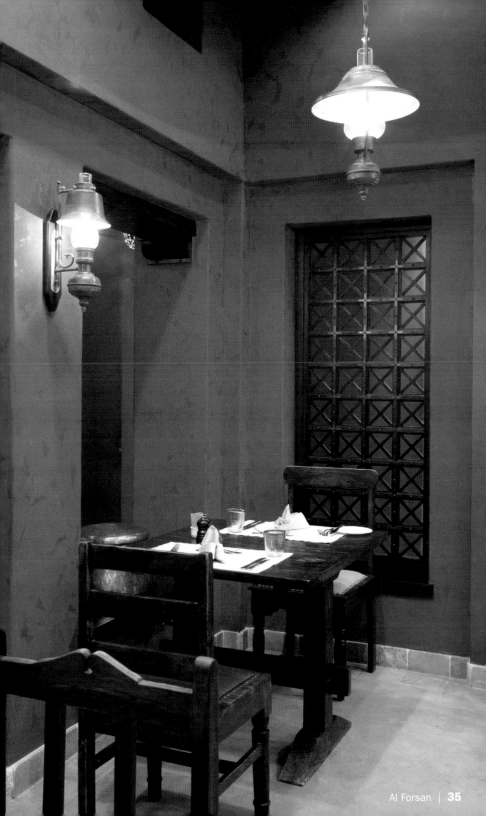

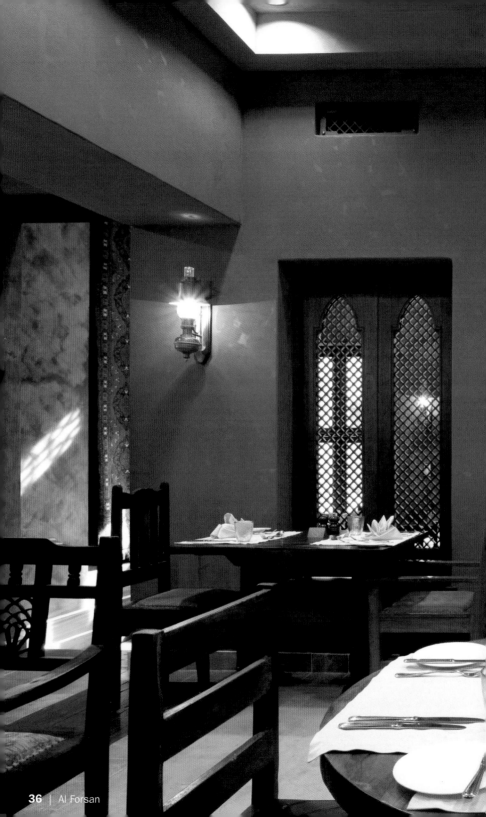

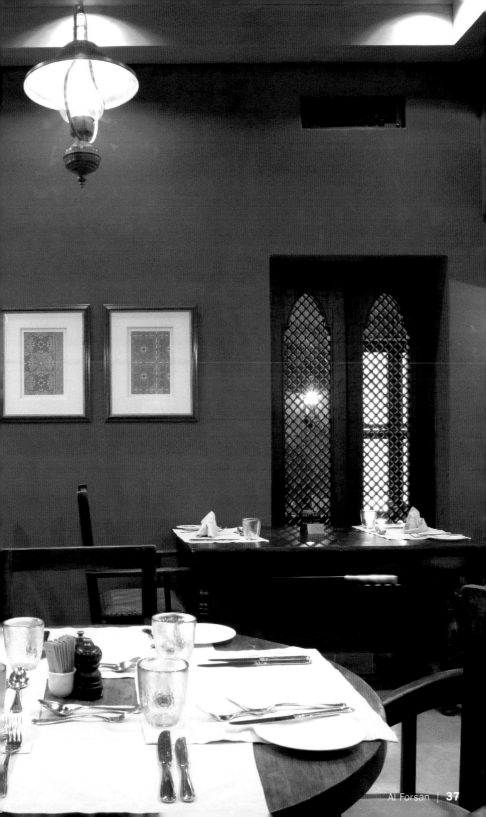

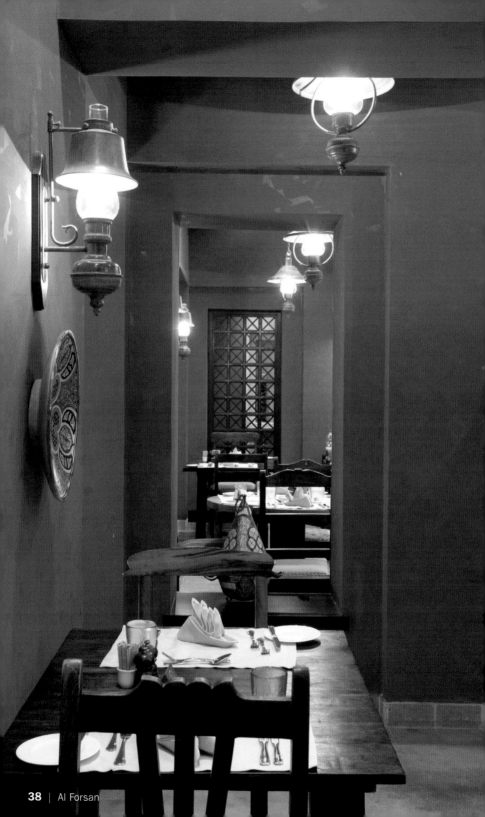

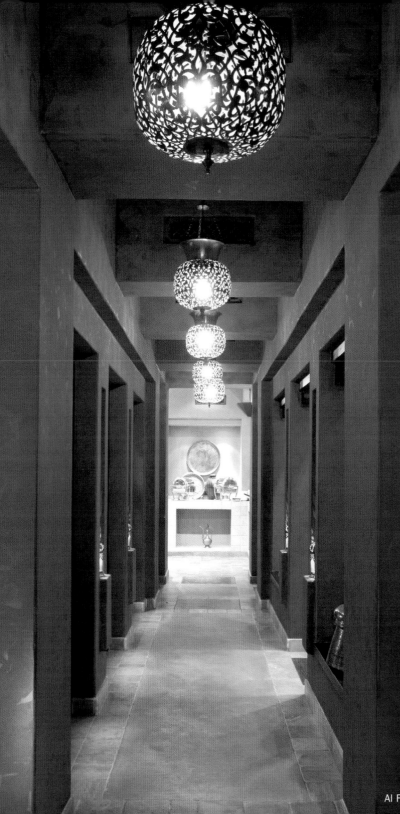

Al Hadheerah

Design: Godwin Austin Johnson | Owner: Jumeirah
Chef: Monal Malhotra

Jumeirah Bab Al Shams Desert Resort & Spa | Dubai
Phone: +971 4 809 6287
www.jumeirah.com
Opening hours: Every day 7 pm to midnight
Menu price: AED 295
Cuisine: Arabic
Special features: Open air desert restaurant, live entertainment and cooking, buffets

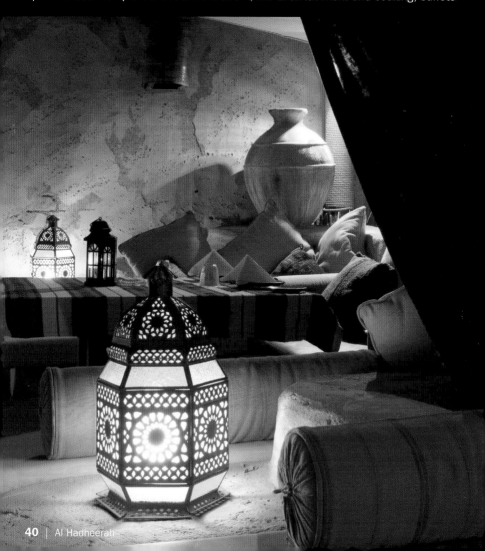

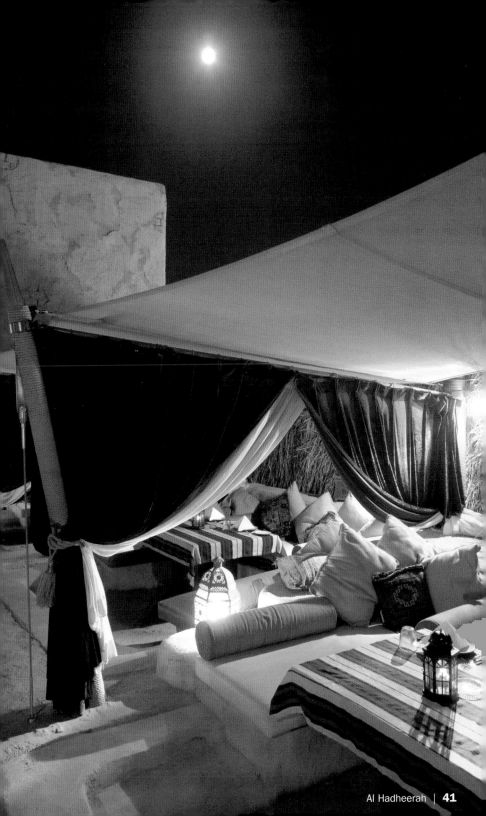

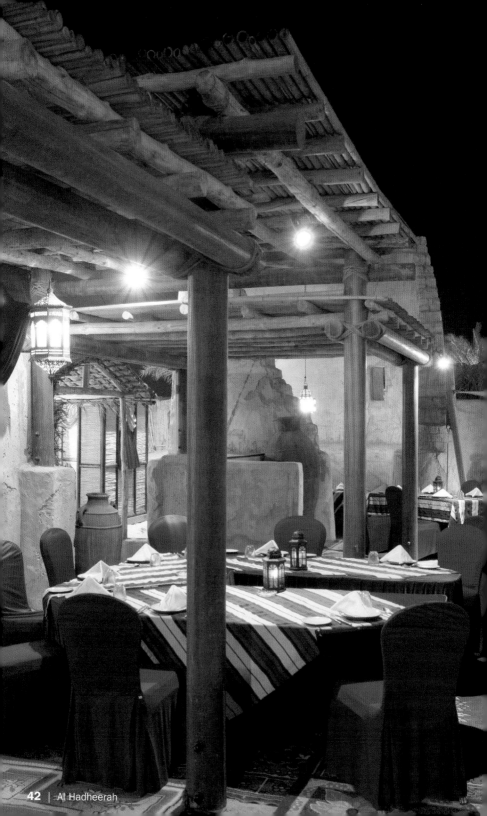

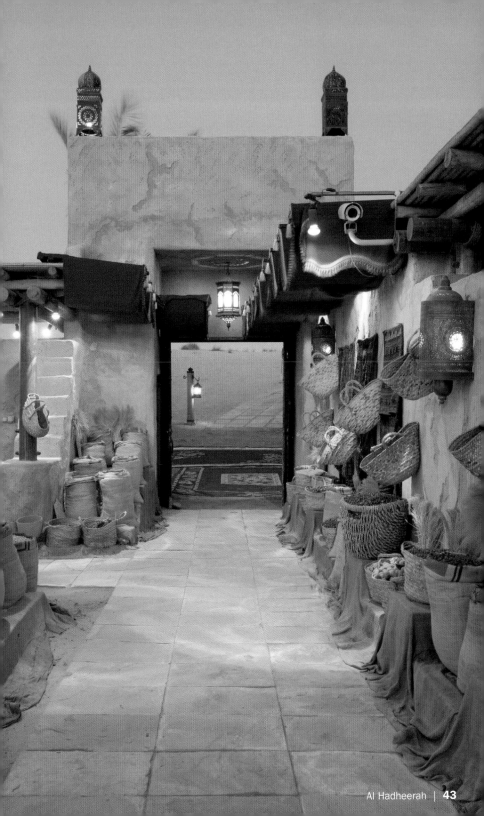

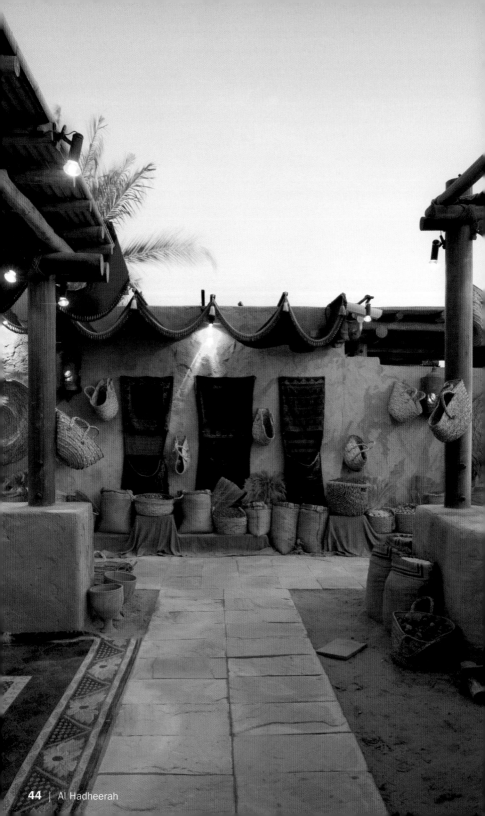

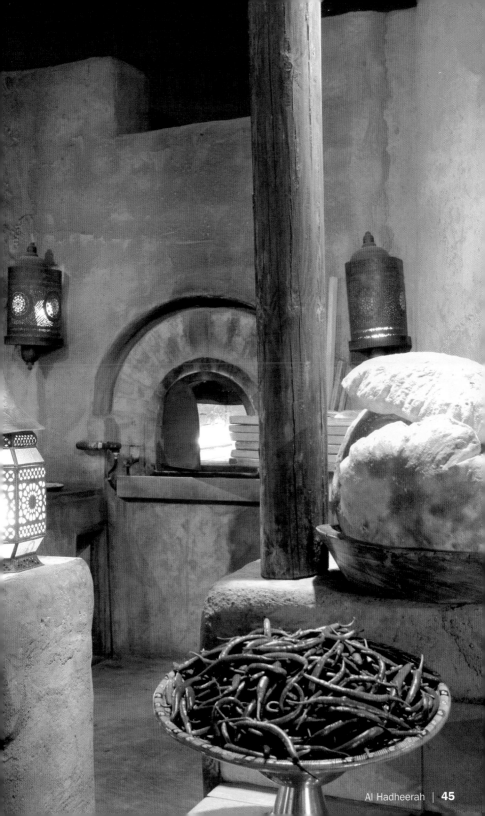

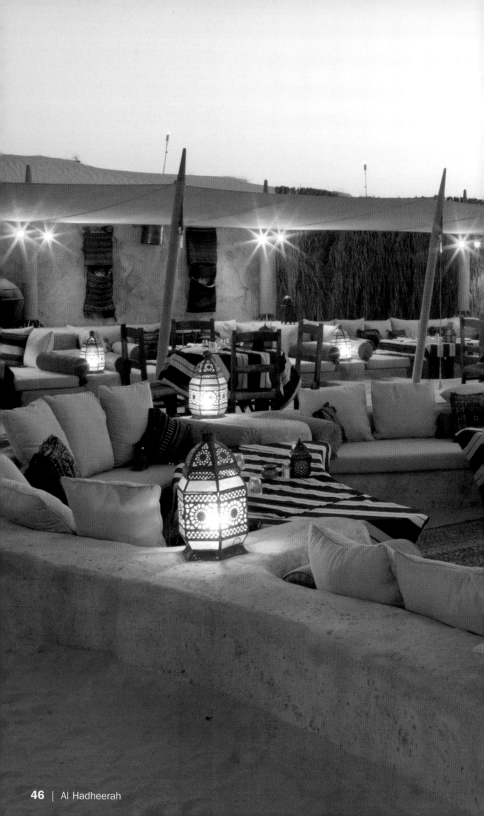

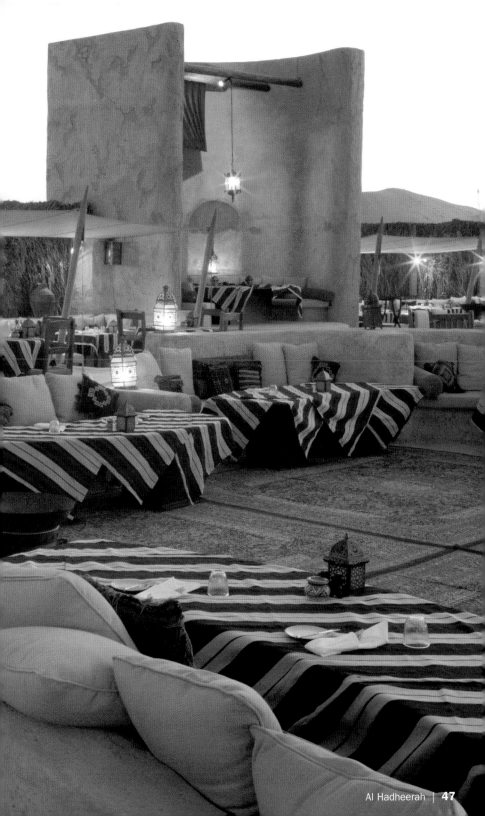

Hoi An

Design: Bilkey Llinas | Owner: Obeid Al Jaber
Chef: Nguyen Trong Phu

Shangri-La Hotel, Dubai, Sheikh Zayed Road | Dubai
Phone: +971 4 343 8888
www.shangri-la.com
Opening hours: Every day dinner 6:30 pm to 1 am
Menu price: AED 95
Cuisine: Vietnamese
Special features: Offering à la carte and set menus. Beverages include specialty
Vietnamese coffees, teas, aperitifs, beers and wines.

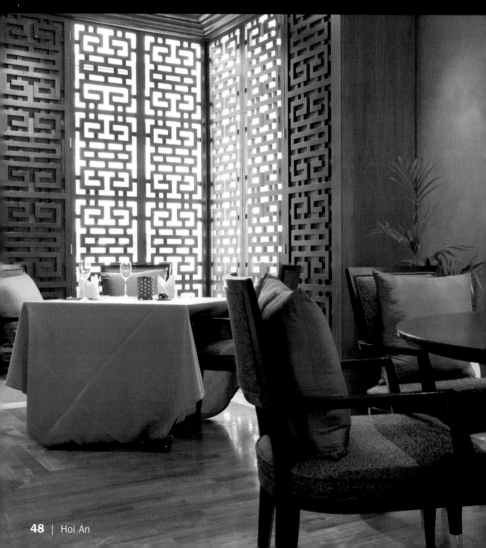

Grilled Lamb
Skewer with Lemongrass

Gegrillter Lammspieß mit Zitronengras

Brochette d'agneau grillée avec citronnelle

Brocheta de cordero a la parrilla con hierba de limón

Spiedo di agnello alla griglia con citronella

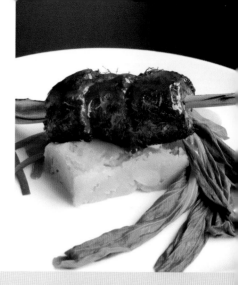

12 pieces lamb tenderloin, 2 oz each
1 clove of garlic, chopped
1 small shallot, chopped
5 sticks lemongrass
2 tbsp fish sauce
2 yams
2 cloves of garlic
1 tbsp corn oil
2 tbsp ginger, chopped
1 tbsp olive oil
500 ml orange juice
Salt, pepper, sugar
Fresh vegetables for decoration
Combine lamb pieces with garlic, shallot, 1 stick chopped lemongrass, fish sauce, salt and pepper and marinate for at least 1 hour.

Wash, peel and cook the yams in salted water for approx. 15 minutes. Sauté the garlic in corn oil, add the cooked yams and mash with a fork. Season with salt and pepper. Sauté the ginger in olive oil, deglaze with orange juice and reduce until it resembles a glace. Season with salt, pepper and sugar.
Remove the lamb pieces from the marinade, place three pieces on one stick lemongrass and grill on a charcoal grill to the desired tenderness.
Spoon the mashed yams onto four plates, place the lamb skewers on top, drizzle with glace and garnish with fresh vegetables.

12 Stücke Lammrücken, à 60 g
1 Knoblauchzehe, gewürfelt
1 kleine Schalotte, gewürfelt
5 Stangen Zitronengras
2 EL Fischsauce
2 Yams
2 Knoblauchzehen
1 EL Maisöl
2 EL Ingwer, gehackt
1 EL Olivenöl
500 ml Orangensaft
Salz, Pfeffer, Zucker
Frisches Gemüse zum Garnieren
Die Lammstücke mit Knoblauch, Schalotte, 1 Stange gehacktem Zitronengras, Fischsauce, Salz und Pfeffer mischen und mindestens 1 Stunde marinieren.

Die Yams waschen, schälen und in gesalzenem Wasser ca. 15 Minuten weich kochen. Den Knoblauch in Maisöl anschwitzen, die gekochten Yams zugeben und mit einer Gabel grob zerdrücken. Mit Salz und Pfeffer würzen. Den Ingwer in Olivenöl anschwitzen, mit Orangensaft ablöschen und so lange kochen, bis die Glace eingedickt ist. Mit Salz, Pfeffer und Zucker abschmecken.
Das Lammfleisch aus der Marinade nehmen, jeweils drei Stücke auf eine Stange Zitronengras stecken und auf einem Holzkohlegrill bis zum gewünschten Garzustand grillen.
Das Yam-Püree auf vier Teller verteilen, die Lammspieße darauf setzen, mit Glace beträufeln und mit frischem Gemüse garnieren.

12 morceaux de carré d'agneau de 60 g chacun
1 gousse d'ail en dés
1 petite échalote en dés
5 branches de citronnelle
2 c. à soupe de sauce de poisson
2 ignames
2 gousses d'ail
1 c. à soupe d'huile de maïs
2 c. à soupe de gingembre haché
1 c. à soupe d'huile d'olive
500 ml de jus d'orange
Sel, poivre, sucre
Légumes frais pour la garniture
Mélanger les morceaux d'agneau avec l'ail, l'échalote, 1 branche de citronnelle hachée, la sauce de poisson, du sel et du poivre et laisser mariner au moins 1 heure.

Laver les ignames, les peler et les cuire complètement dans de l'eau salée pendant env. 15 minutes. Faire suer l'ail dans l'huile de maïs, ajouter les ignames cuits et les écraser grossièrement à la fourchette. Saler et poivrer. Faire suer le gingembre dans de l'huile d'olive, mouiller avec le jus d'orange et faire cuire jusqu'à ce que le déglacé ait épaissit. Rectifier l'assaisonnement avec du sel, du poivre et du sucre.
Retirer la viande de la marinade, embrocher respectivement trois morceaux sur une branche de citronnelle et faire cuire sur le grill jusqu'à obtention de la cuisson désirée.
Répartir la purée d'igname sur quatre assiettes, déposer les brochettes d'agneau, arroser de déglacé et garnir de légumes frais.

12 trozos de costilla de cordero de 60 g cada uno
1 diente de ajo picado
1 escalonia picada
5 ramas de hierba de limón
2 cucharadas de salsa de pescado
2 boniatos
2 dientes de ajo
1 cucharada de aceite de maíz
2 cucharadas de jengibre picado
1 cucharada de aceite de oliva
500 ml de zumo de naranja
Sal, pimienta, azúcar
Verdura fresca para decorar
Dejar en marinada durante 1 hora los trozos de cordero con ajo, escalonia, 1 rama de hierba de limón picada, salsa de pescado, sal y pimienta.

Lavar los boniatos, pelarlos y cocerlos en agua con sal hasta que estén blandos durante 15 minutos aprox. Sofreír el ajo en aceite de maíz, añadir los boniatos cocidos, aplastarlos ligeramente con un tenedor y salpimentarlos. Sofreír en aceite de oliva el jengibre, rociarlo con zumo de naranja y cocerlo hasta que el almíbar esté espeso. Sazonarlo con sal, pimienta y azúcar.
Sacar el cordero de la marinada, insertar tres trozos por cada rama de hierba de limón y hacerlos a la parrilla con carbón vegetal al punto deseado.
Repartir el puré de boniatos en cuatro platos, colocar las brochetas de cordero, rociarlas con el almíbar y decorarlas con verdura fresca.

12 pezzi di schiena di agnello di 60 g ciascuno
1 spicchio d'aglio tritato
1 piccolo scalogno tagliato a dadini
5 rametti di citronella
2 cucchiai di sugo di pesce
2 yam
2 spicchi d'aglio
1 cucchiaio di olio di mais
2 cucchiai di zenzero tritato
1 cucchiaio di olio di oliva
500 ml di succo d'arancia
Sale, pepe, zucchero
Verdure fresche per la guarnizione
Mescolare i pezzi di agnello con l'aglio, lo scalogno, 1 rametto di citronella tritata, il sugo di pesce, sale, pepe. Lasciar marinare per almeno 1 ora.

Lavare gli yam, sbucciarli e cuocerli in acqua salata per circa 15 minuti finché teneri. Rosolare l'aglio nell'olio di mais, unire gli yam cotti e schiacciare il tutto grossolanamente con una forchetta. Salare e pepare. Dorare lo zenzero nell'olio di oliva, bagnarlo con il succo d'arancia e cuocerlo finché la glassa non si sia rappresa. Salare, pepare e zuccherare.
Estrarre la carne di agnello dalla marinata, infilarne tre pezzi su ogni rametto di citronella e cuocerla alla brace fino al punto desiderato.
Ripartire la purea di yam in quattro piatti, disporvi sopra gli spiedini di agnello, pillottarli con la glassa e guarnire con le verdure fresche.

Jambase

Design: Khuan Chew of KCA International | Owner: Jumeirah
Chef: Heiko Schreiner

Madinat Jumeirah-Souk | Dubai
Phone: +971 4 366 6914
www.jumeirah.com
Opening hours: Every day dinner 7 pm to 11:30 pm
Menu price: AED 180
Cuisine: International
Special features: Jazz music, live concerts

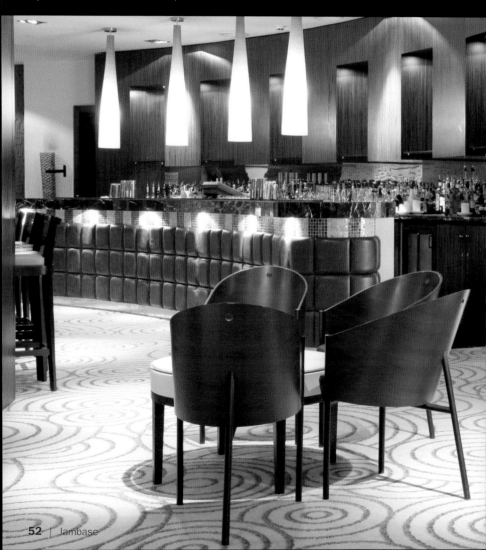

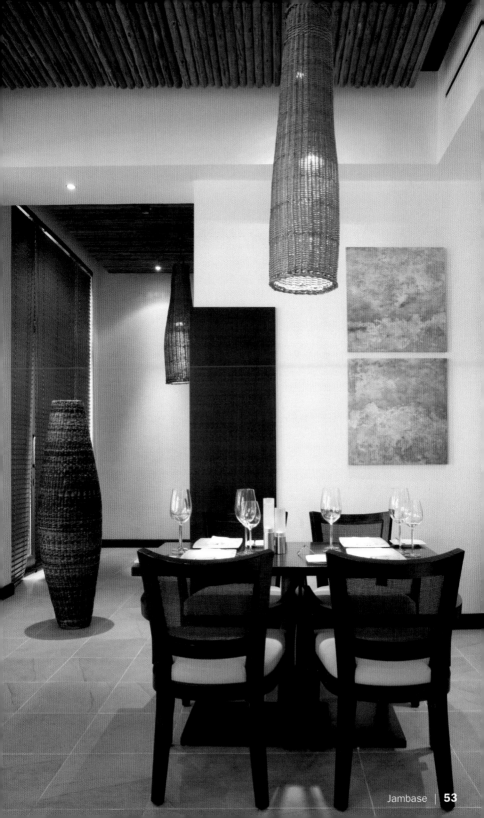

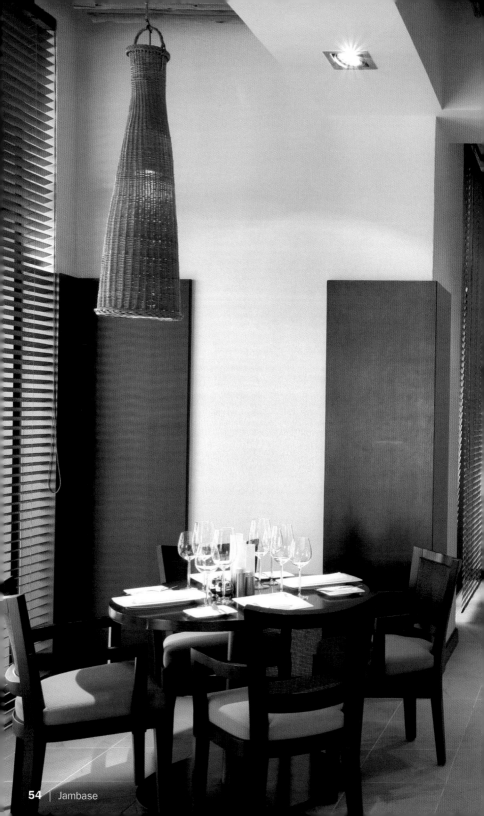

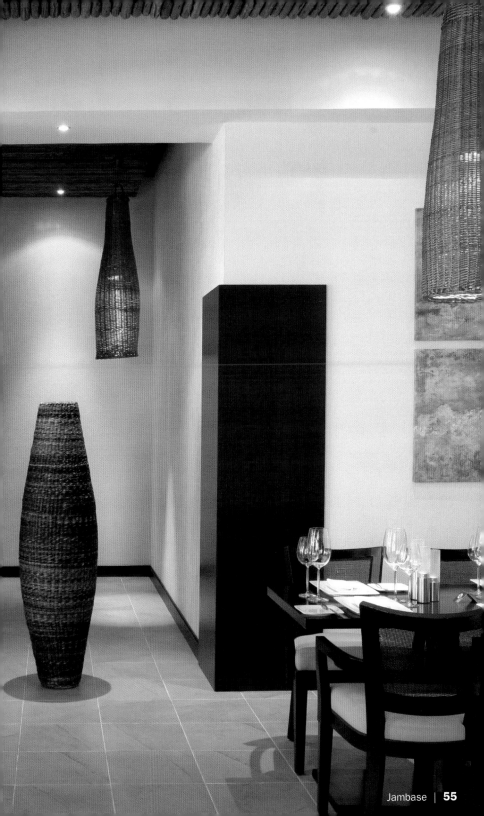

The Junction

Design: Interior Motives | Owner: Zubair Corporation
Chef: C. Sudusinghe

TRADERS HOTEL by Shangri-La
Corner of Abu Baker Al Siddique & Salah Al Din Road | Deira – Dubai
Phone: +971 4 214 7272
www.tradershotels.com
Opening hours: Open 24 hours
Menu price: AED 95
Cuisine: International and local
Special features: Breakfast, lunch and dinner buffets, à la carte combos, inclusive soft
drinks or alcoholic beverages

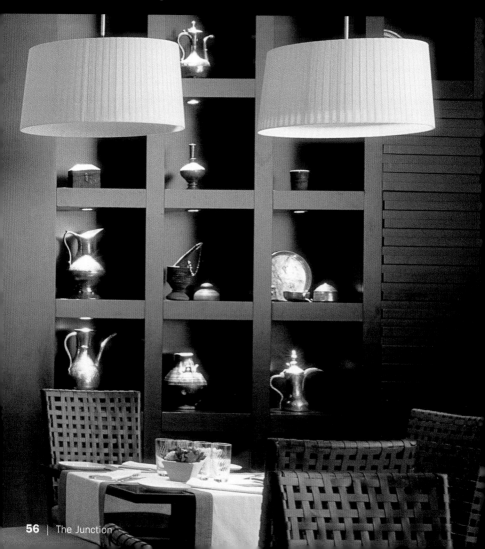

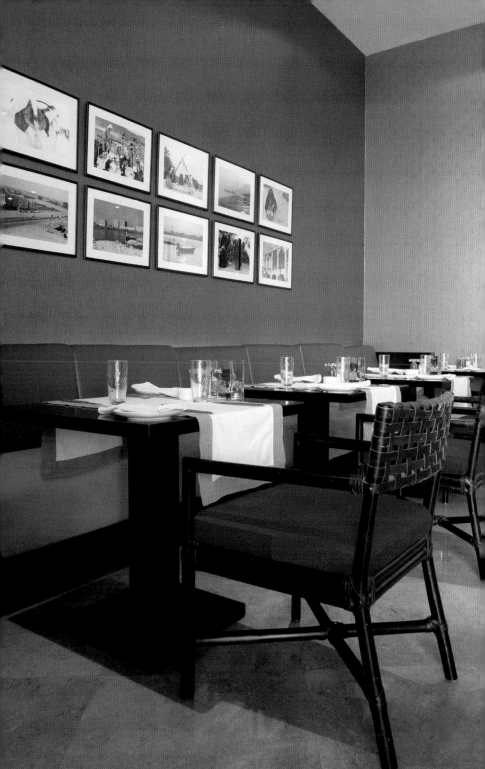

Al Mahara

Design: Khuan Chew of KCA International | Owner: Jumeirah
Chef: Jean-Paul Naquin

Burj Al Arab | Dubai
Phone: +971 4 301 7160
www.jumeirah.com
Opening hours: Every day lunch 12:30 pm to 2:30 pm, dinner 7 pm to midnight
Menu price: AED 700–900
Cuisine: Seafood with Asian touch
Special features: Fantastic view over the sea

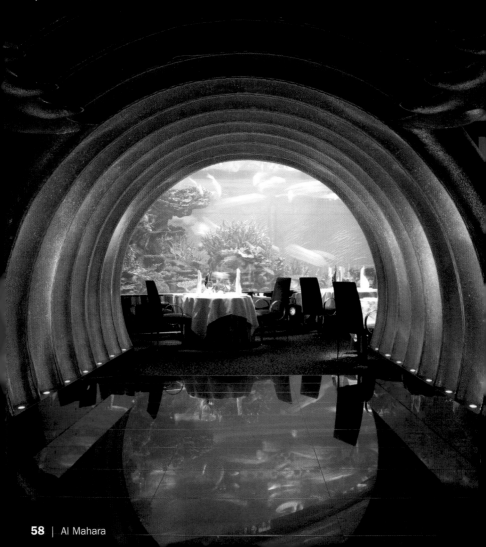

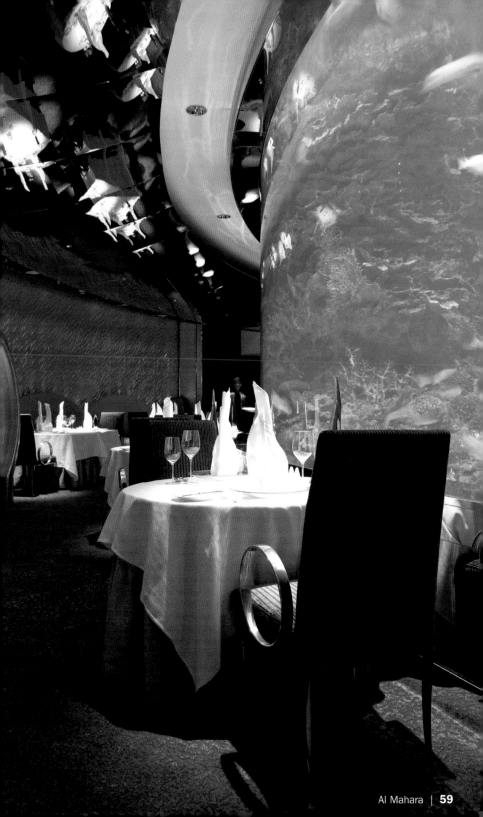

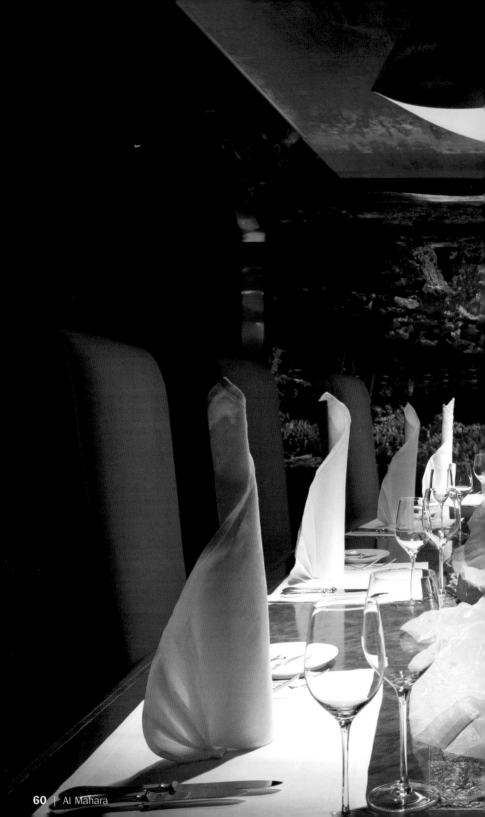

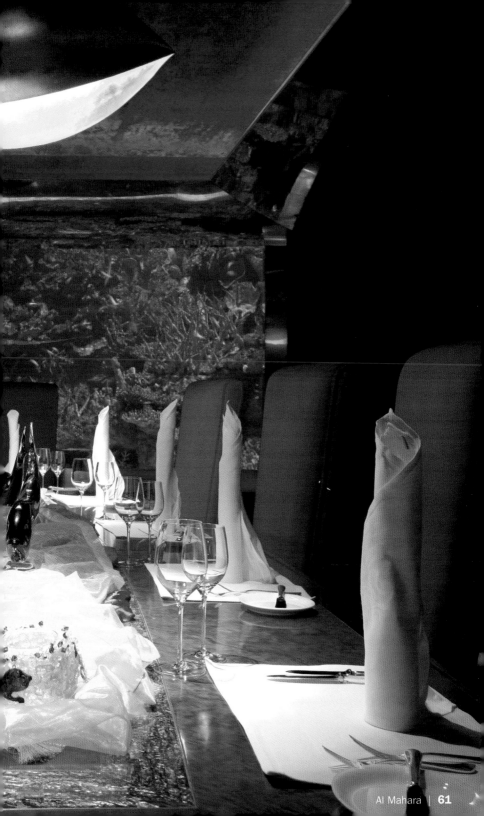

Warm Lobster Sashimi

Warmes Hummer-Sashimi
Sashimi de homard chaud
Sashimi caliente de bogavante
Sashimi caldo di astice

2 lobster (whole and alive)
4 baby carrots, cooked and cut in thirds
4 baby zucchini, cooked and cut in half diagonally
3 oz baby Tat Soy (Japanese lettuce)
1 beetroot, cooked and thinly sliced
1 black truffle, thinly sliced
Cook the lobster in salted water for 6 minutes, chill, break apart and divide into four portions.

4 oz crab meat
Approx. 10 saffron threads
1/2 tsp ginger
1 tbsp tomato paste
Salt, chili powder
Sauté all ingredients, season, mash and pour through a strainer. Keep warm.

800 ml fish stock
13 1/2 oz potatoes, peeled and diced
120 ml cream
2 tbsp butter
Boil the potatoes in the fish stock until tender, mash and season with cream, butter, salt and pepper. Keep warm.

1 small shallot, diced
1/4 clove of garlic, chopped
1 tsp olive oil
80 ml white wine
80 ml fish stock, 80 ml cream
1 tsp white truffle oil
Sauté shallot and garlic in oil, deglaze with white wine, fish stock and cream, bring to a boil, mash, strain and season with truffle oil, salt and pepper. Froth. Arrange ingredients as shown on the picture.

2 Hummer (ganz und lebendig)
4 Fingermöhren, gegart und gedrittelt
4 Baby-Zucchini, gegart und schräg halbiert
90 g Baby Tat Soy (japanischer Salat)
1 Rote Bete, gegart und in dünnen Scheiben
1 schwarzer Trüffel, in dünnen Scheiben
Die Hummer in kochendem Salzwasser 6 Minuten garen, auskühlen lassen, ausbrechen und in vier Portionen aufteilen.

120 g Krebsfleisch
ca. 10 Safranfäden
1/2 TL Ingwer
1 EL Tomatenmark
Salz, Chilipulver
Alle Zutaten andünsten, abschmecken, pürieren und durch ein Sieb gießen. Warm stellen.

800 ml Fischfond
400 g Kartoffeln, geschält und gewürfelt
120 ml Sahne
2 EL Butter
Die Kartoffeln in dem Fischfond gar kochen, pürieren und mit Sahne, Butter, Salz und Pfeffer abschmecken. Warm stellen.

1 kleine Schalotte, gewürfelt
1/4 Knoblauchzehe, gehackt
1 TL Olivenöl
80 ml Weißwein
80 ml Fischfond, 80 ml Sahne
1 TL weißes Trüffelöl
Schalotte und Knoblauch in Öl anschwitzen, mit Weißwein, Fischfond und Sahne ablöschen, aufkochen, pürieren, abseihen und mit Trüffelöl, Salz und Pfeffer abschmecken. Aufschäumen. Zutaten wie auf dem Foto arrangieren.

2 homards (entiers et vivants)
4 carottes doigt de Paris, cuites, coupées en trois
4 mini courgettes, cuites, coupées en deux en biseau
90 g de laitue tatsoy (salade japonaise)
1 betterave rouge cuite, en fines tranches
1 truffe noire en fines tranches
Faire cuire les homards dans de l'eau bouillante
salée 6 minutes, laisser refroidir, décortiquer et
découper quatre portions.

120 g de chair de crabe
Env. 10 fils de safran
1/2 c. à café de gingembre
1 c. à soupe de concentré de tomates
Sel, poudre de piment
Faire mijoter tous les ingrédients, assaisonner,
réduire en purée et passer au chinois. Mettre
au chaud.

800 ml de fond de poisson
400 g de pommes de terre épluchées, en dés
120 ml de crème
2 c. à soupe de beurre
Bien faire cuire les pommes de terre avec le
fond de poisson, réduire en purée et assaison-
ner avec la crème, le beurre, du sel et du poivre.
Mettre au chaud.

1 petite échalote en dés
1/4 de gousse d'ail hachée
1 c. à café d'huile d'olive
80 ml de vin blanc
80 ml de fond de poisson, 80 ml de crème
1 c. à café d'huile blanc de truffe
Faire suer l'ail et l'échalote dans l'huile, mouiller
avec le vin, le fond et la crème, donner un tour
de bouillon, réduire en purée, passer au chinois
et assaisonner d'huile de truffe, sel et poivre.
Faire mousser. Dresser comme sur la photo.

2 bogavantes (vivos y enteros)
4 zanahorias cocidas y cortadas en tercios
4 calabacines enanos cocidos y cortados trans-
versalmente
90 g de Baby Tat Soy (lechuga japonesa)
1 remolacha cocida y en rodajas finas
1 trufa negra en láminas finas
Cocer los bogavantes en agua hirviendo con sal
durante 6 minutos, dejarlos enfriar, abrirlos y
cortarlos en cuatro porciones.

120 g de carne de cangrejo
10 hilos de azafrán aprox.
1/2 cucharadita de jengibre
1 cucharada de concentrado de tomate
Sal, chiles en polvo
Rehogar todos los ingredientes, sazonar-
los, hacerlos puré y pasarlos por un colador.
Reservar en caliente.

800 ml de fondo de pescado
400 g de patatas peladas y troceadas en dados
120 ml de nata
2 cucharadas de mantequilla
Cocer las patatas en el fondo de pescado,
hacerlas puré y sazonarlas con nata, mantequi-
lla, sal y pimienta. Reservarlas en caliente.

1 escalonia pequeña picada
1/4 de diente de ajo picado
1 cucharadita de aceite de oliva
80 ml de vino blanco
80 ml de fondo de pescado, 80 ml de nata
1 cucharadita de aceite de trufa blanca
Sofreír la escalonia y el ajo en aceite, rociarla con
vino blanco, fondo de pescado y nata. Llevarla a ebu-
llición, hacerla puré, colarla y sazonarla con aceite
de trufa, sal y pimienta. Batir la mezcla. Disponer los
ingredientes como aparece en la foto.

2 astici (vivi e interi)
4 piccole carote cotte e tagliate in tre pezzi
4 zucchini piccoli cotti e dimezzati nel senso
della lunghezza
90 g di Baby Tat soy (insalata giapponese)
1 barbabietola rossa cotta e tagliata a fette sottili
1 tartufo nero tagliato a fette sottili
Lessare gli astici in acqua bollente salata per 6
minuti, lasciarli raffreddare, aprirli e dividerli in
quattro porzioni.

120 g di polpa di granchio
Circa 10 fili di zafferano
1/2 cucchiaino di zenzero
1 cucchiaio di concentrato di pomodoro
Sale, peperoncino in polvere
Lessare tutti gli ingredienti, regolare il condimen-
to, ridurli in purea e scolarli. Tenere al caldo.

800 ml di fondo di pesce
400 g di patate sbucciate e tagliate a dadini
120 ml di panna
2 cucchiai di burro
Cuocere le patate nel fondo di pesce, passarle
al passaverdura e condirle con panna, burro,
sale e il pepe. Tenere al caldo.

1 piccolo scalogno tagliato a dadini
1/4 di spicchio d'aglio tritato
1 cucchiaino di olio di oliva
80 ml di vino bianco
80 ml di fondo di pesce, 80 ml di panna
1 cucchiaino di olio al tartufo bianco
Dorare nell'olio lo scalogno e l'aglio, bagnarli con
il vino bianco, il fondo di pesce e la panna. Farli
rosolare brevemente, passarli al passaverdura e al
setaccio e condirli con l'olio al tartufo, sale e pepe.
Schiumare. Disporre gli ingredienti come nella foto.

Manhattan Grill

Owner: Grand Hyatt Dubai | Chef: Jordi Serra

Grand Hyatt Dubai | Dubai
Phone: +971 4 317 1234
www.dubai.grand.hyatt.com
Opening hours: Sat–Wed lunch 12:30 pm to 3 pm, dinner 7 pm to 11:30 pm;
Thu–Fri lunch 12:30 pm to 3 pm, dinner 7 pm to 1 am
Menu price: AED 290
Cuisine: American Grill

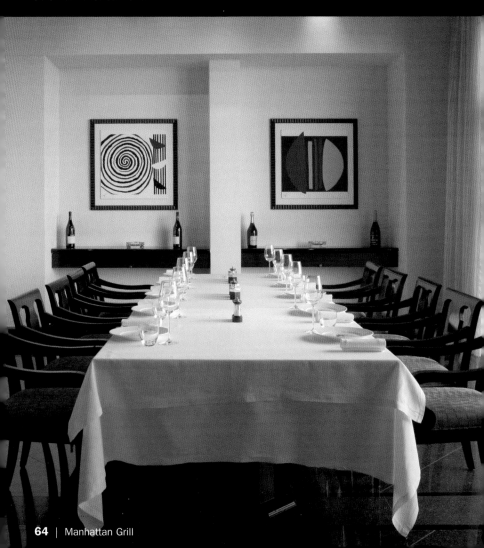

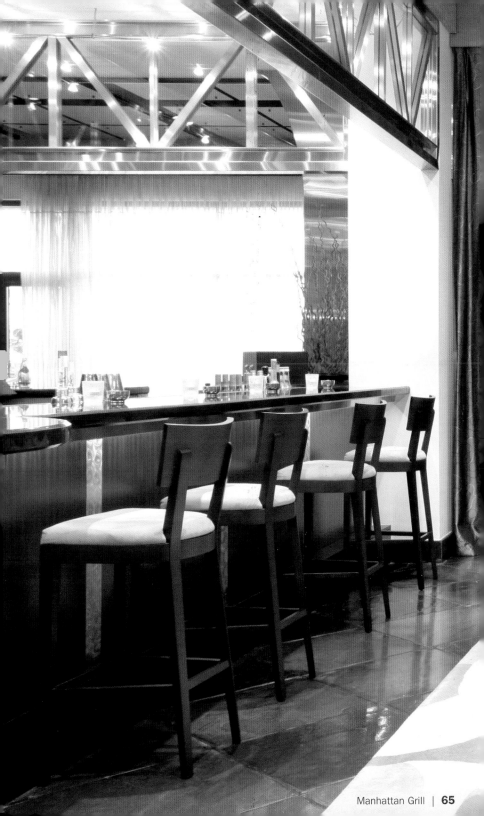

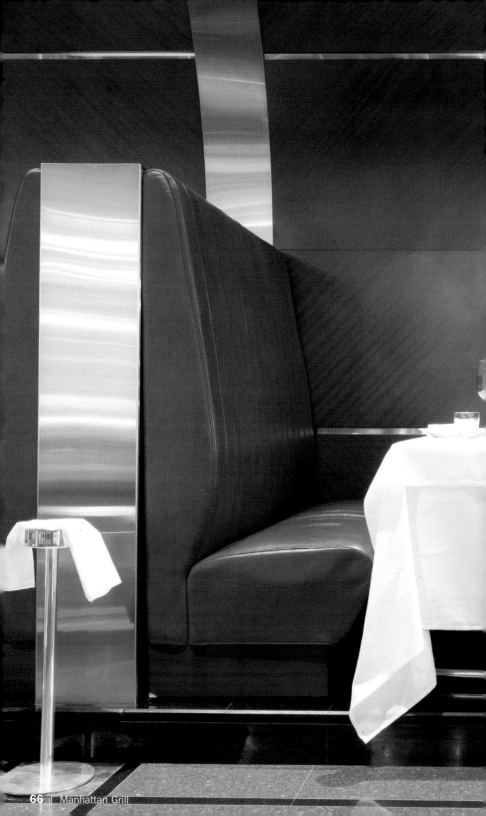

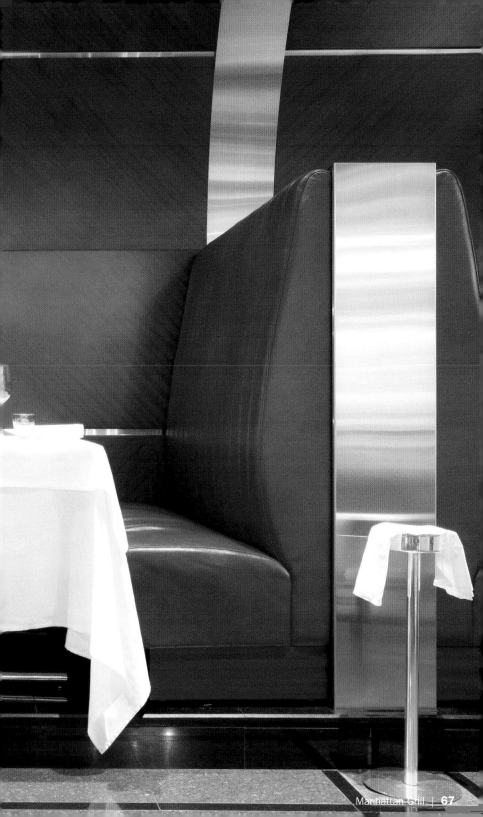

Toasted Goat Cheese

on Mango Salad

Gratinierter Ziegenkäse auf Mangosalat

Fromage de chèvre gratiné et salade de mangue

Queso de cabra gratinado sobre ensalada de mango

Formaggio di capra gratinato con insalata di mango

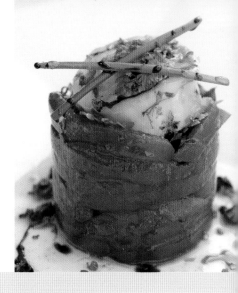

2 round goat cheese (Picandou), cut in half horizontally
4 slices potato, the same diameter as the cheese
1 tbsp olive oil
Thyme, rosemary, bay leaf
100 ml chicken stock
Salt, pepper

Sear the potato slices in olive oil, add the herbs and deglaze with chicken stock. Cook until the potatoes are soft, the liquid has evaporated and the potato slices are coated with fond. Season with salt and pepper and place one slice goat cheese on top. Toast the goat cheese until it's golden brown.

1 pomegranate
4 oz black olives, chopped
3 oz honey
50 ml lemon juice
100 ml olive oil
Salt, pepper, chopped thyme
Remove the seeds from the pomegranate and carefully combine all ingredients. Season.

12 tomato fillets
4 oz young lettuce
2 mangos, in julienne
Coat a metal ring with 3 tomato fillets, mix the mango juliennes with half of the dressing and fill the rings with it. Stuff with lettuce and cover with a slice potato-goat cheese. Spread the leftover dressing amongst the plates.

2 runde Ziegenkäse (Picandou), horizontal halbiert
4 Kartoffelscheiben, im gleichen Durchmesser wie der Käse
1 EL Olivenöl
Thymian, Rosmarin, Lorbeerblatt
100 ml Geflügelbrühe
Salz, Pfeffer

Die Kartoffelscheiben in Öl anbraten, die Kräuter zugeben und mit der Geflügelbrühe ablöschen. Solange köcheln lassen, bis die Kartoffel weich, die Flüssigkeit einreduziert und die Kartoffelscheiben glasiert sind. Salzen und pfeffern und jeweils eine Scheibe Ziegenkäse auf eine Kartoffelscheibe legen. Den Ziegenkäse kurz grillen, bis er goldbraun ist.

1 Granatapfel
120 g schwarze Oliven, gehackt
90 g Honig
50 ml Zitronensaft
100 ml Olivenöl
Salz, Pfeffer, gehackter Thymian
Die Kerne aus dem Granatapfel lösen und alle Zutaten vorsichtig mischen. Abschmecken.

12 Tomatenfilets
120 g junger Salat
2 Mangos, in Julienne
Mit jeweils 3 Tomatenfilets einen Metallring auskleiden, die Mango-Julienne mit der Hälfte des Dressings mischen und in die Ringe füllen. Mit Salat auffüllen und mit einer Kartoffel-Ziegenkäse-Scheibe bedecken. Das restliche Dressing auf den Tellern verteilen.

2 fromages de chèvre ronds (Picandou), coupés
en deux horizontalement
4 tranches de pomme de terre du même diamè-
tre que le fromage
1 c. à soupe d'huile d'olive
Thym, romarin, feuille de laurier
100 ml de bouillon de volaille
Sel, poivre

Faire revenir les tranches de pomme de terre
dans l'huile, ajouter les herbes et mouiller avec
le bouillon de volaille. Laisser mijoter jusqu'à
ce que la pomme de terre soit tendre, le liquide
réduit et les tranches de pomme de terre trans-
parentes. Saler, poivrer et déposer une tranche
de fromage de chèvre sur chaque tranche de
pomme de terre. Dorer le fromage au grill quel-
ques instants.

1 grenade
120 g d'olives noires hachées
90 g de miel
50 ml de jus de citron
100 ml d'huile d'olive
Sel, poivre, thym haché
Détacher les pépins de la grenade et mélanger
tous les ingrédients avec précaution. Rectifier
l'assaisonnement.

12 filets de tomate
120 g de jeune laitue
2 mangues en julienne
Garnir un cercle en métal avec respectivement 3
filets de tomate, mélanger la julienne de mangue
avec la moitié de la sauce de salade et en remplir les
cercles. Compléter avec la salade et recouvrir d'une
tranche de pomme de terre au fromage de chèvre.
Répartir le reste de la sauce sur les assiettes.

2 quesos de cabra (Picandou) redondos y corta-
dos por la mitad horizontalmente
4 rodajas de patata del mismo diámetro que
el queso
1 cucharada de aceite de oliva
Tomillo, romero y laurel
100 ml de caldo de ave
Sal, pimienta

Saltear las rodajas de patata en aceite, añadir
las hierbas y rociarlas con el caldo de ave. Cocer
las patatas hasta que estén blandas y glasea-
das y el líquido se haya reducido. Salpimentar
y colocar respectivamente una lámina de queso
de cabra sobre cada rodaja de patata. Hacer al
grill el queso hasta que esté dorado.

1 granada
120 g de aceitunas negras picadas
90 g de miel
50 ml de zumo de limón
100 ml de aceite de oliva
Sal, pimienta, tomillo picado
Quitar las pepitas a las granadas y mezclar con cui-
dado todos los ingredientes. Por último sazonar.

12 láminas de tomate
120 g de lechuga joven
2 mangos en juliana
Cubrir cada anillo de metal con 3 láminas de
tomate respectivamente, mezclar la juliana de
mango con la mitad del aliño y rellenar los
anillos con ella. Completarlos con la lechuga y
cubrirlos con una rodaja de patata con queso de
cabra. Rociar el resto del aliño por el plato.

2 formaggi caprini rotondi (Picandou), dimezzati
orizzontalmente
4 fette di patate dello stesso diametro del
formaggio
1 cucchiaio di olio di oliva
Timo, rosmarino, foglia d'alloro
100 ml di brodo di pollo
Sale, pepe

Rosolare nell'olio le fette di patate, aggiungere
le erbe e bagnarle con il brodo di pollo. Lasciar
cuocere lentamente finché il liquido non si sarà
ristretto e le patate non saranno tenere e dorate.
Salare e pepare. Disporre una fetta di formaggio
su ogni fetta di patata. Dorare il formaggio pas-
sandolo brevemente sotto la griglia.

1 melagrana
120 g di olive nere tritate
90 g di miele
50 ml di succo di limone
100 ml di olio di oliva
Sale, pepe, timo tritato
Staccare i semi dalla melagrana e mescolare delica-
tamente tutti gli ingredienti. Regolare il condimento.

12 filetti di pomodoro
120 g di insalata giovane
2 mango tagliati alla julienne
Rivestire un anello di metallo con 3 filetti di pomo-
doro, mescolare le strisce di mango con metà del
dressing e riempire gli anelli, continuando la farcitura
con l'insalata. Coprire con una fetta di formaggio e
di patata. Ripartire nei piatti il resto del dressing.

Marrakech

Design: David Wren Associates | Owner: Obeid Al Jaber
Chef: Chef Khadja Manar

Shangri-La Hotel, Dubai, Sheikh Zayed Road | Dubai
Phone: +971 4 343 8888
www.shangri-la.com
Opening hours: Thu–Sun dinner 6:30 pm to 1 am, closed on Mondays
Menu price: AED 95
Cuisine: Moroccan
Special features: Private dining in arched alcoves

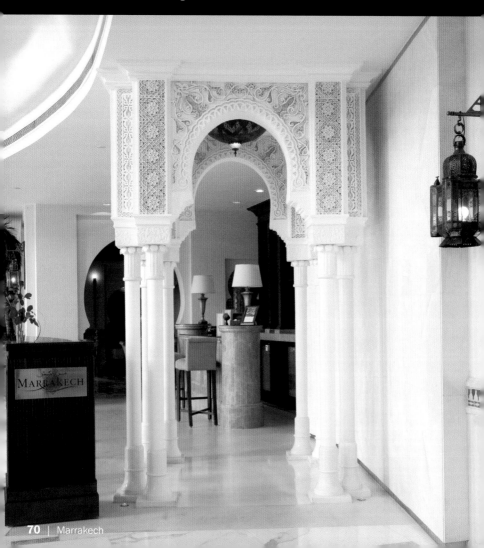

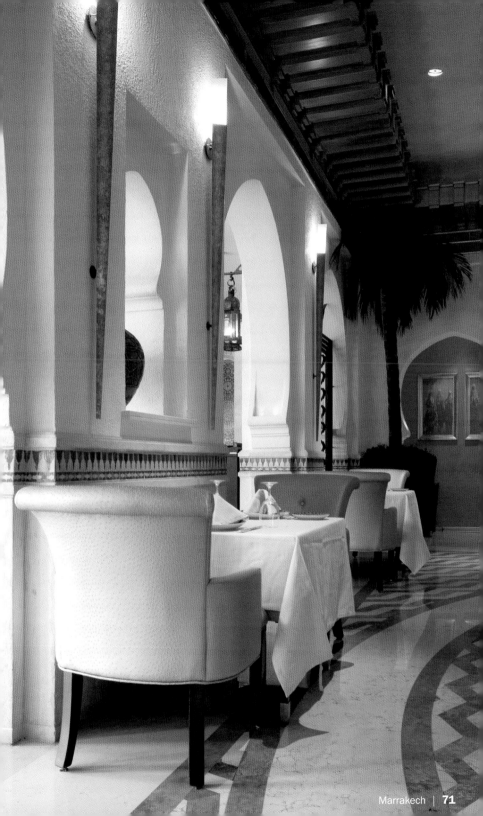

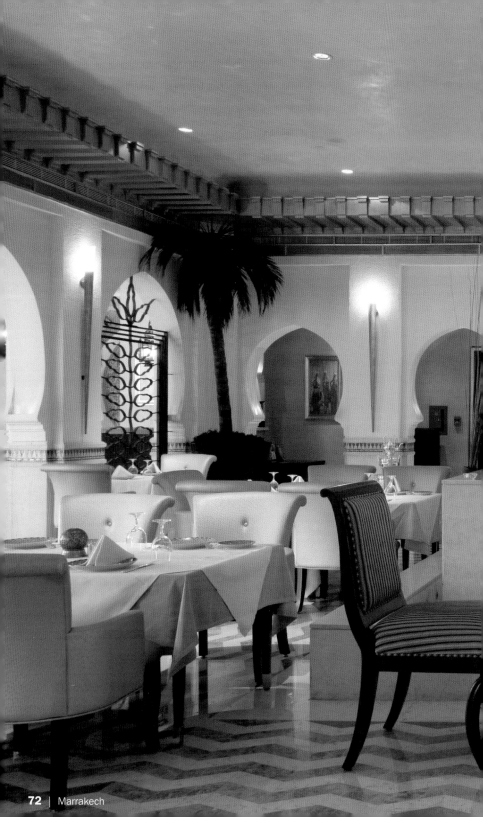

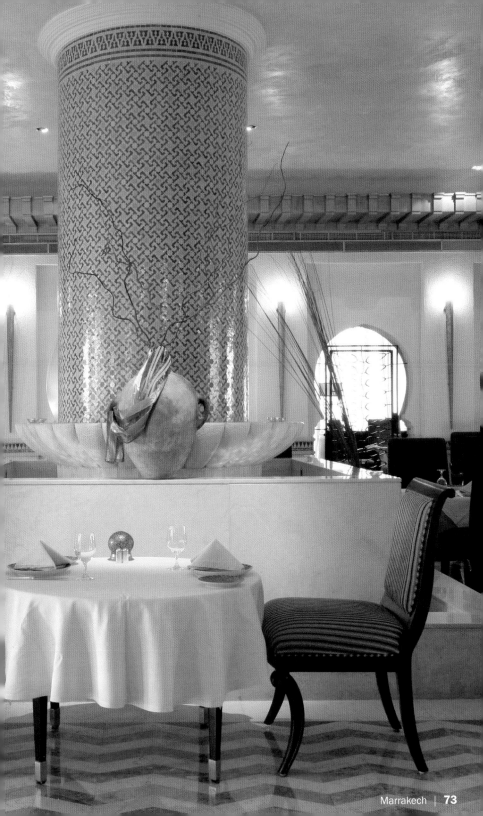

Seafood Soup

Meeresfrüchtesuppe
Soupe de fruits de mer
Sopa de marisco
Zuppa di frutti di mare

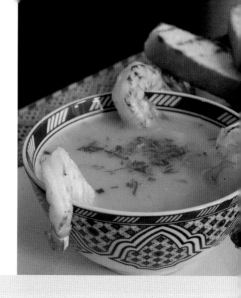

1 onion, diced
3 tbsp olive oil
Approx. 10 saffron threads
13 1/2 oz shrimp, cleaned
13 1/2 oz calamari, cut in rings
Salt, pepper
1 tbsp parsley, chopped
1 tbsp cilantro, chopped
2 l fish stock
12 prawns, cleaned
2 tbsp olive oil
Chopped cilantro for decoration
8 slices toasted baguette

Sauté the onion in olive oil, add the shrimp and calamari and sear for approx. 5 minutes, season, add the saffron and herbs and deglaze with fish stock. Simmer for 10 minutes.
In the meantime sear the prawns in hot oil from both sides, season and toast the baguette. Again, season the soup, pour into soup bowls and serve with prawns, cilantro and sliced baguette.

1 Zwiebel, gewürfelt
3 EL Olivenöl
Ca. 10 Safranfäden
400 g Shrimps, geputzt
400 g Calamari, in Ringe geschnitten
Salz, Pfeffer
1 EL Petersilie, gehackt
1 EL Koriander, gehackt
2 l Fischfond
12 Garnelen, geputzt
2 EL Olivenöl
Gehackter Koriander zur Dekoration
8 Scheiben getoastetes Baguette

Die Zwiebel in Olivenöl anschwitzen, die Shrimps und Calamari zugeben und ca. 5 Minuten anbraten. Die Meeresfrüchte würzen, den Safran und die Kräuter zugeben und mit dem Fischfond auffüllen. 10 Minuten köcheln lassen.
In der Zwischenzeit die Garnelen in heißem Öl von beiden Seiten anbraten, würzen und das Baguette toasten. Die Suppe nochmals abschmecken, in Suppenschalen füllen und mit Garnelen, Koriander und Baguettescheiben servieren.

1 oignon en dés
3 c. à soupe d'huile d'olive
Env. 10 fils de safran
400 g de crevettes décortiqués
400 g de calmars en rondelles
Sel, poivre
1 c. à soupe de persil haché
1 c. à soupe de coriandre hachée
2 l de fond de poisson
12 langoustines décortiqués
2 c. à soupe d'huile d'olive
Coriandre hachée pour la décoration
8 tranches de baguette toastées

Faire suer les oignons dans l'huile d'olive, ajouter les crevettes et les calmars et faire revenir env. 5 minutes, assaisonner, incorporer le safran et les herbes et mouiller avec le fond de poisson. Laisser frémir 10 minutes.
Entre-temps faire revenir les langoustines des deux côtés dans l'huile chaude, assaisonner et toaster la baguette. Rectifier éventuellement l'assaisonnement de la soupe, verser dans des bols à soupe et servir avec les langoustines, la coriandre et les tranches de baguette.

1 cebolla picada
3 cucharadas de aceite de oliva
10 hilos de azafrán aprox.
400 g de langostinos limpios
400 g de calamares cortados en anillas
Sal, pimienta
1 cucharada de perejil picado
1 cucharada de cilantro picado
2 l de fondo de pescado
12 gambas limpias
2 cucharadas de aceite de oliva
Cilantro picado para decorar
8 rebanadas tostadas de baguette

Sofreír la cebolla en aceite de oliva, añadir los calamares y los langostinos, rehogarlos durante 5 minutos. Sazonar los mariscos, añadir el azafrán y las hierbas y completar con el fondo de pescado. Cocer durante 10 minutos.
Entretanto saltear las gambas por las dos caras en aceite de oliva, sazonarlas y tostar la baguette. Volver a sazonar la sopa, verterla en cuencos y servirla con las gambas, el cilantro y las rebanadas de baguette.

1 cipolla tagliata a dadini
3 cucchiai di olio di oliva
Circa 10 fili di zafferano
400 g di gamberetti puliti
400 g di calamari tagliati ad anelli
Sale, pepe
1 cucchiaio di prezzemolo tritato
1 cucchiaio di coriandolo tritato
2 l di fondo di pesce
12 gamberi puliti
2 cucchiai di olio di oliva
Coriandolo tritato per la guarnizione
8 fette tostate di baguette

Rosolare la cipolla nell'olio di oliva, unire i gamberetti e i calamari e cuocerli per circa 5 minuti. Condire, aggiungere lo zafferano e le erbe e riempire con il fondo di pesce. Lasciar cuocere a fuoco lentissimo per 10 minuti.
Nel frattempo, dorare i gamberi nell'olio caldo da entrambi i lati e condirli. Tostare la baguette. Assaggiare e regolare nuovamente il condimento, versare la zuppa nei piatti e servire con i gamberi, il coriandolo e le fette di baguette.

Miyako

Design: LWDesign Group LLC | Chef: Yukio Tukeda
Owner: Hyatt Regency Dubai

Hyatt Regency Dubai | Dubai
Phone: + 971 4 209 1234
Opening hours: Every day lunch 12:30 pm to 3 pm, dinner 7 pm to midnight
Menu price: AED 200–300
Cuisine: Japanese

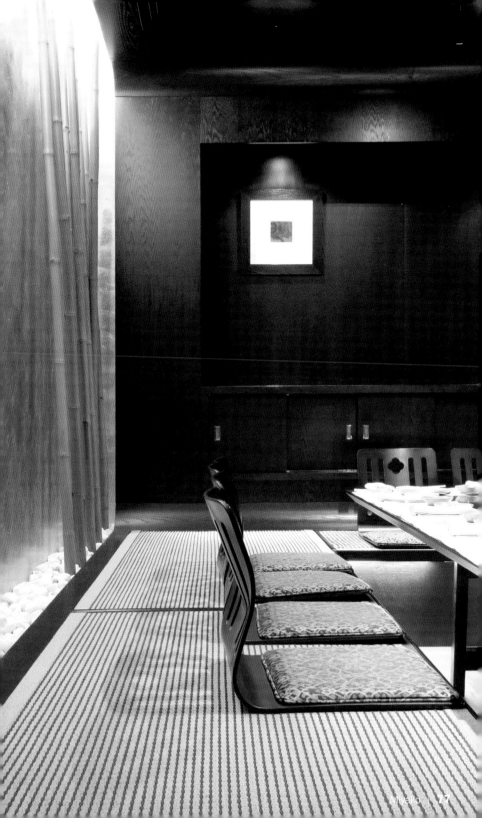

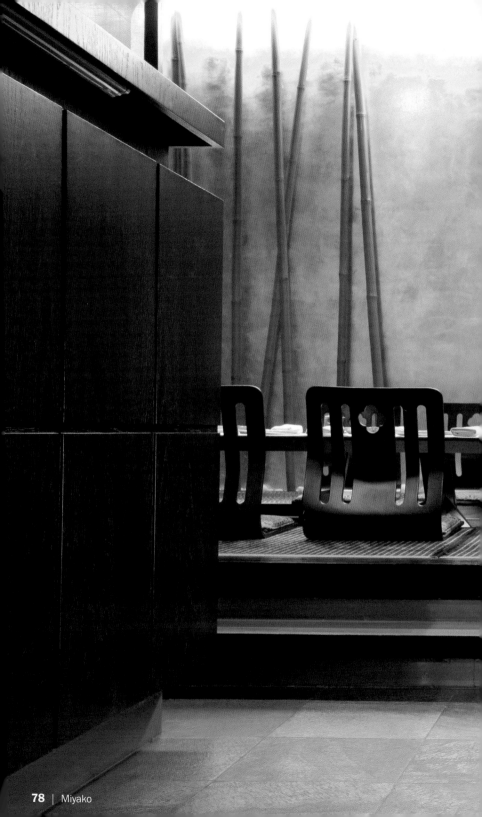

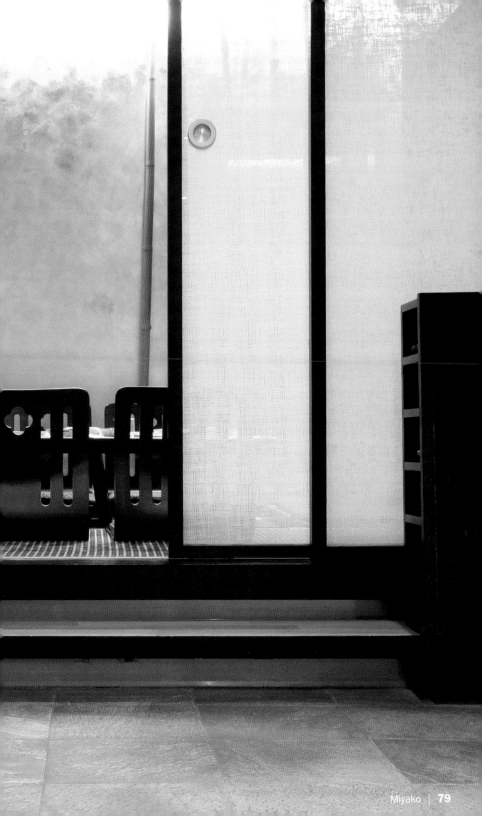

Nina

Design: Wilson & Associates | **Owner:** One&Only Royal Mirage
Chef: Lew Kathreptis

Royal Mirage, Jumeirah Road | Dubai
Phone: +971 4 339 9999
www.oneandonlyroyalmirage.com
Opening hours: Mon–Sun 7 pm to 11:15 pm (last order), closed on Fridays
Menu price: AED 65
Cuisine: Indo-European
Special features: Honeymooner menu

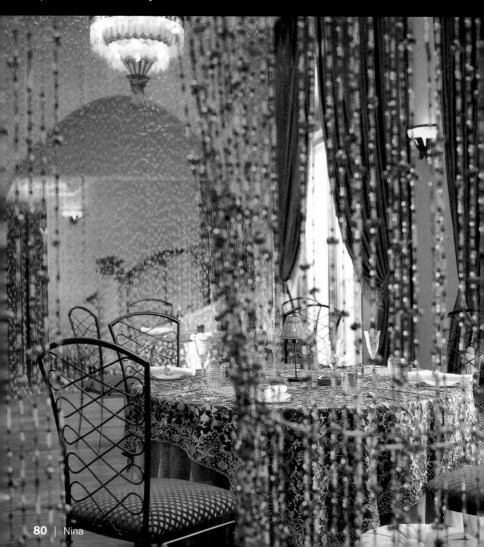

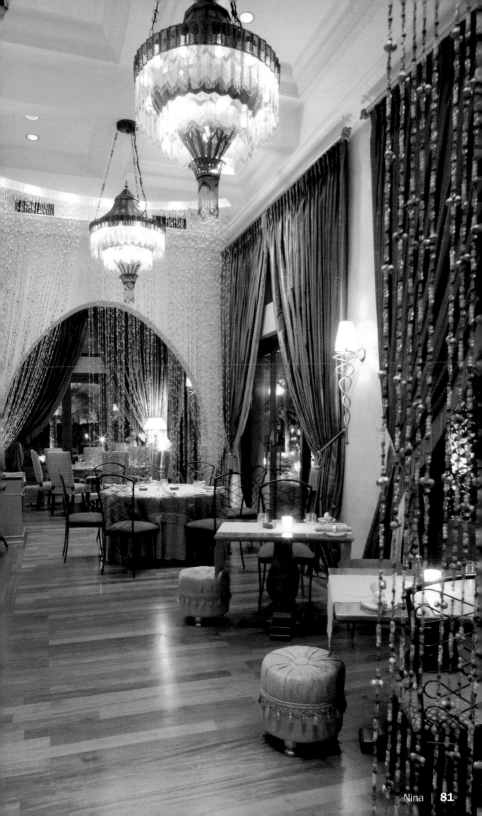

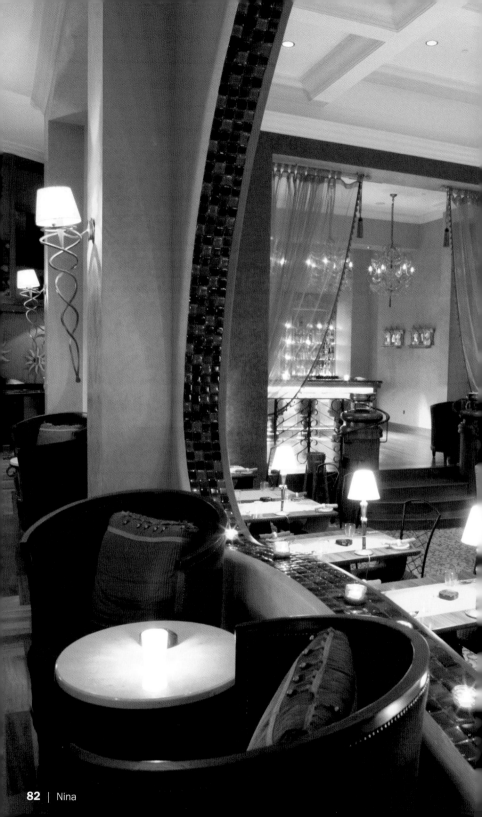

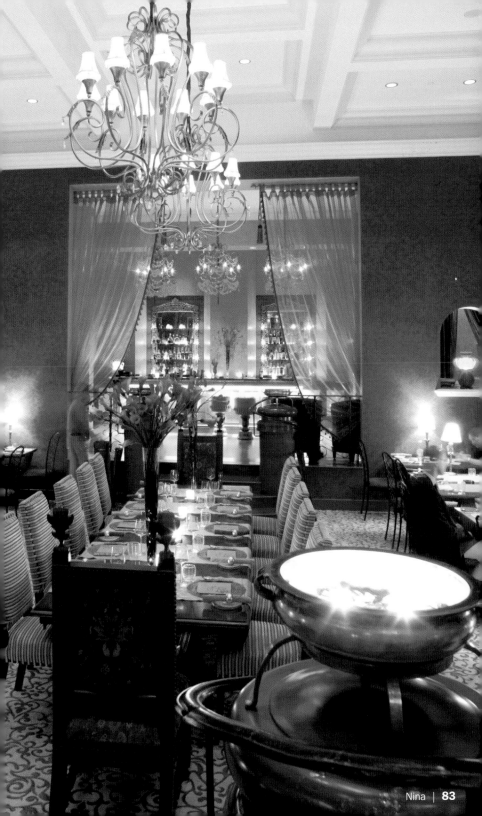

The Noodle House

Design: LWDesign Group LLC | Owner: Jumeirah
Chef: Luigi Gerosa

Deira City Center | Dubai
Phone: +971 4 294 0885
www.thenoodlehouse.com
Opening hours: Sat–Thu 10 am to midnight, Fri noon to midnight
Menu price: AED 65
Cuisine: South East Asian

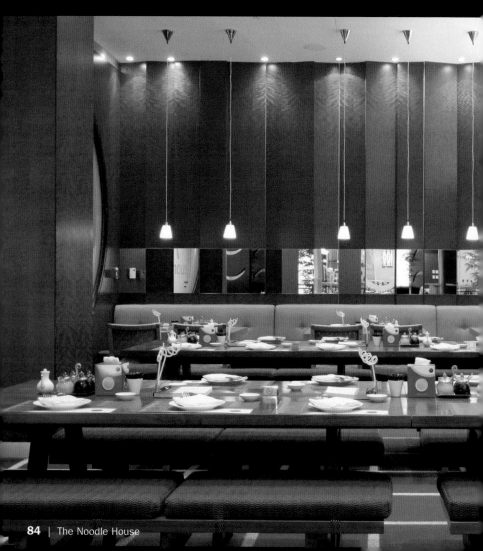

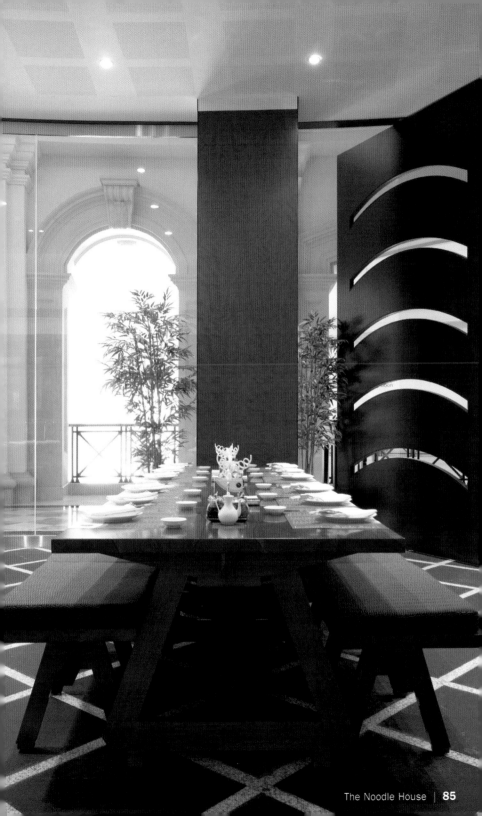

The Noodle House | **85**

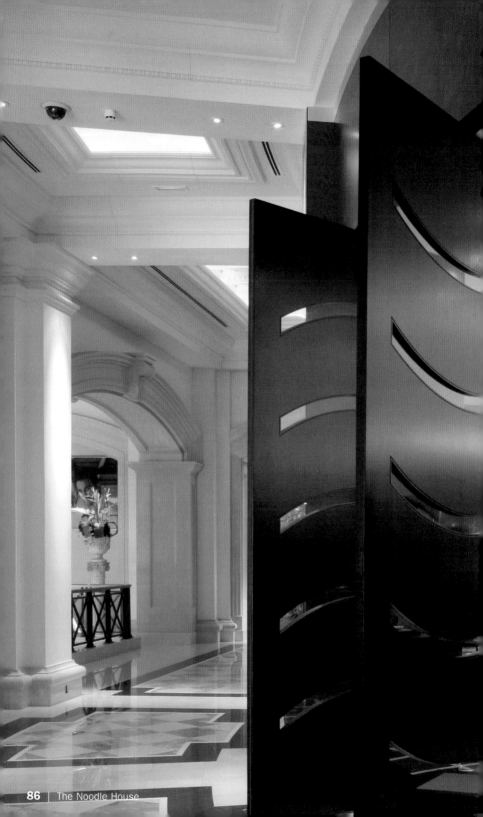

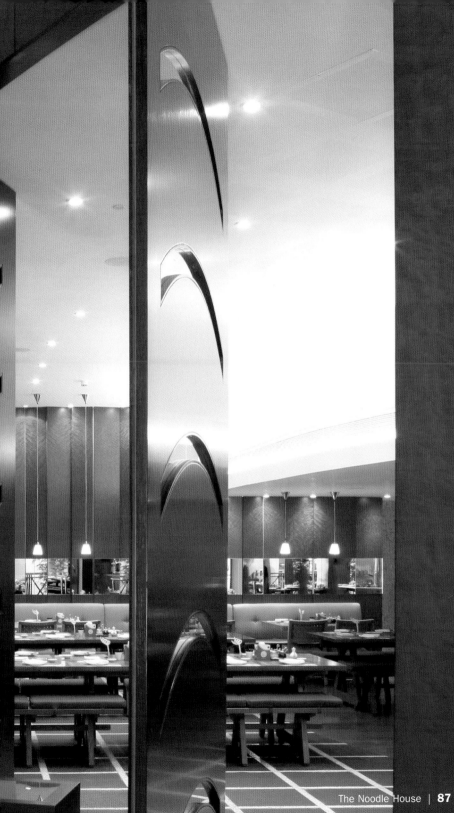

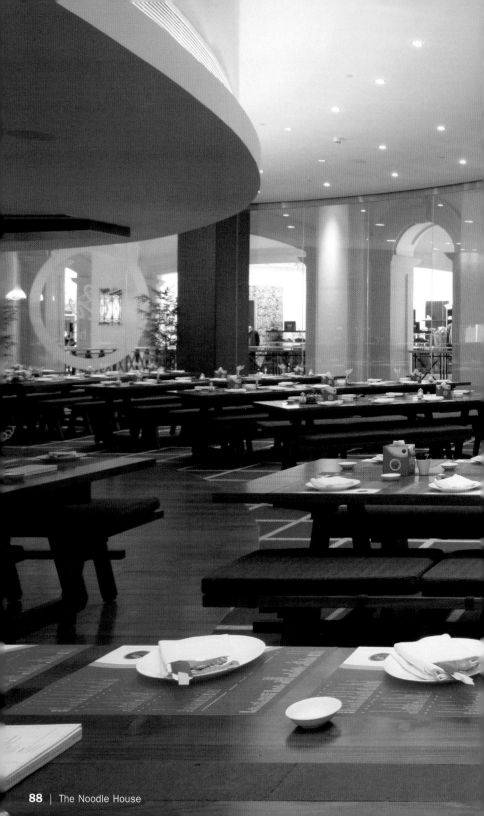

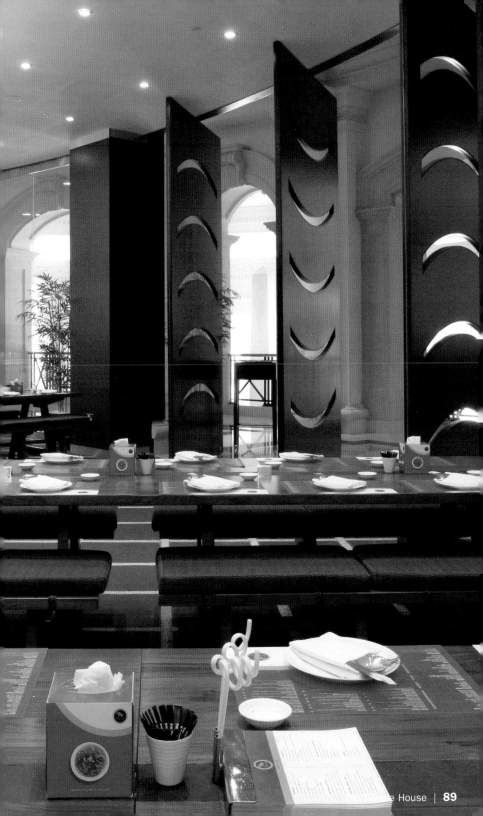

Pierchic

Owner: Jumeirah | Chef: Heiko Schreiner

Madinat Jumeirah, Al Sufouh Road | Dubai
Phone: +971 4 366 6125
www.jumeirah.com
Opening hours: Everyday lunch noon to 3 pm, dinner 7 pm to 11:30 pm
Menu price: AED 500
Cuisine: Seafood
Special features: Located at the end of a wooden pier, Pierchic boasts incredible views
of the Arabian Gulf, Madinat Jumeirah and the Burj Al Arab

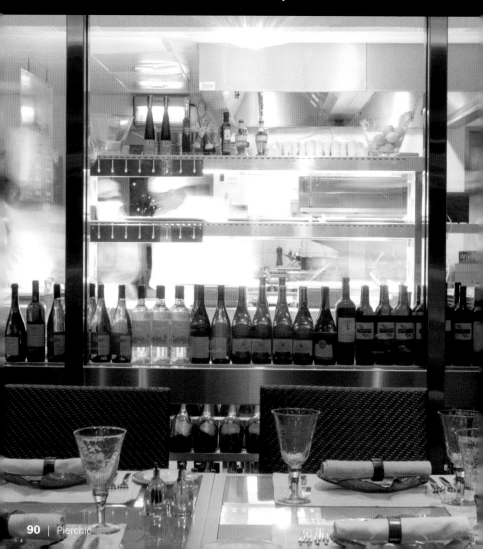

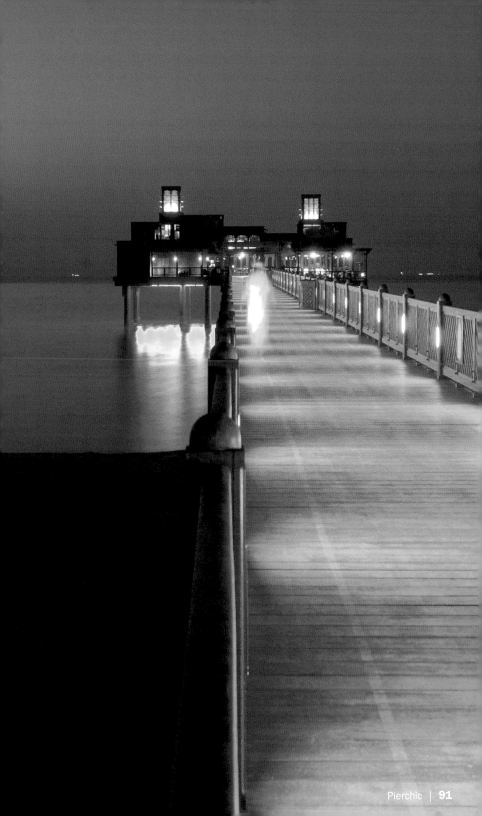

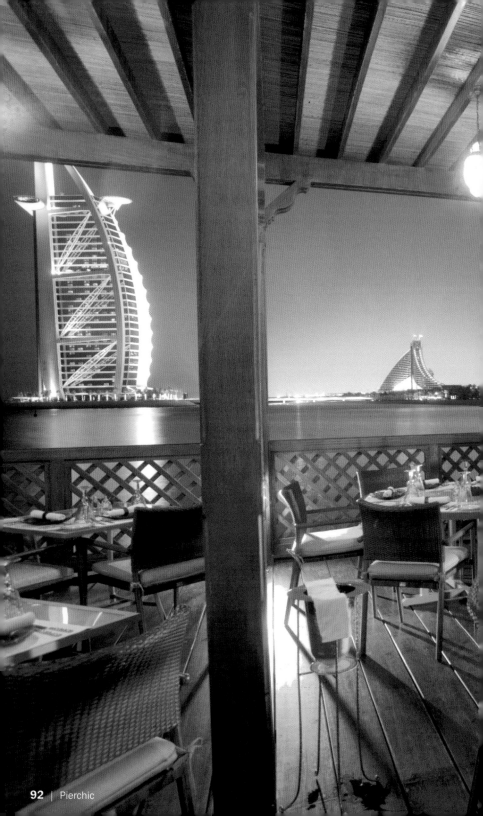

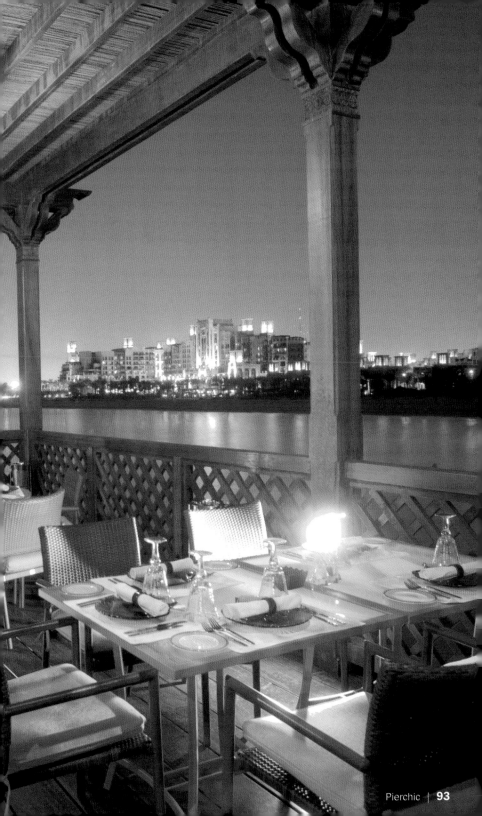

Pisces

Design: Khuan Chew of KCA International | Owner: Jumeirah
Chef: Heiko Schreiner

Madinat Jumeirah-Souk | Dubai
Phone: +971 4 366 6313
www.jumeirah.com
Opening hours: Every day dinner 7 pm to 11:30 pm
Menu price: AED 380
Cuisine: Contemporary seafood
Special features: Bar included

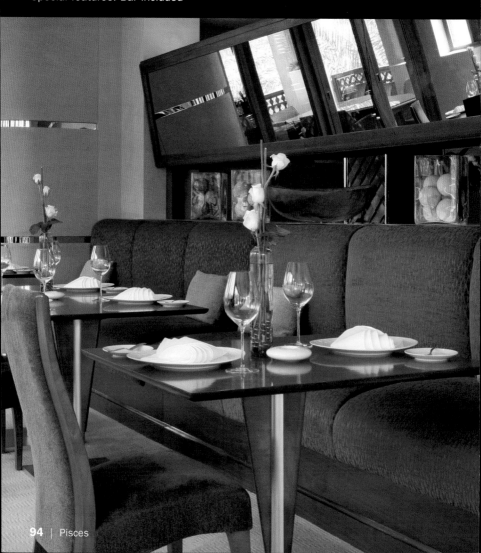

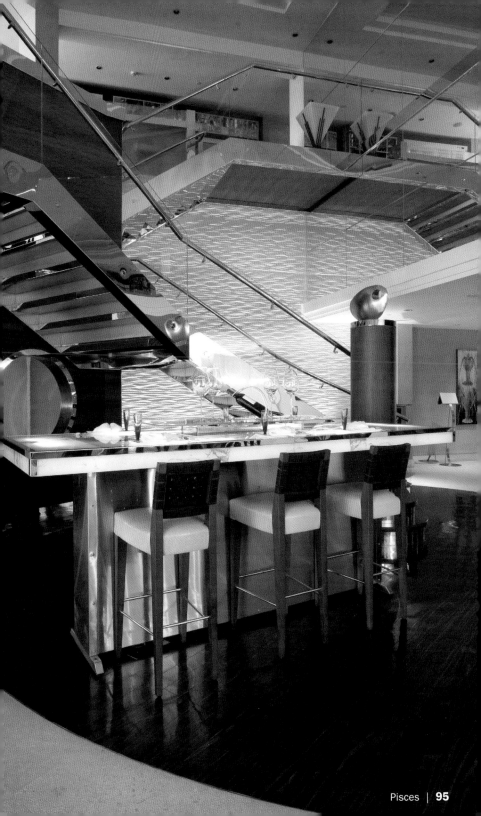

Red Mullet Tarte
with Eggplant

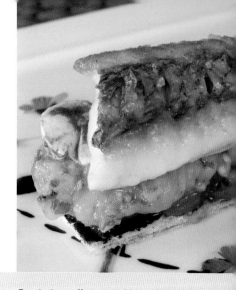

Meerbarben-Tarte mit Aubergine
Tarte au rouget et à l'aubergine
Tarta de salmonete de roca con berenjenas
Tarte di triglie con melanzane

4 red mullet fillets, 4 oz each
4 sheets puff pastry, the same size as the red mullet
1 egg yolk
1 bag sepia-ink
2 eggplants
4 tbsp olive oil
2 cloves of garlic
2 twigs thyme
Lemon juice, salt, pepper
8 baby mozzarella, sliced
8 cherry tomatoes, sliced
4 tsp pesto
4 tbsp cress

Brush the puff pastry with a mixture of egg yolk and sepia-ink and bake at 360 °F for approx. 8 minutes. Set aside.
Cut the eggplants in half, sprinkle with salt to draw the juices and sear from all sides in olive oil with garlic and thyme. Bake in a 360 °F oven until soft. Scrape the soft meat out of the skin and season with lemon juice, salt and pepper.

Season the red mullet fillets, sear on the skin side until crispy and keep warm.
Place the puff pastry on four plates, cover with tomato slices, brush with pesto, spoon mashed eggplant on top, place the mozzarella slices on the eggplant, season and sprinkle with cress. Top with one red mullet fillet and garnish the plate with herbs and vinegar.

4 Meerbarbenfilets, à 120 g
4 Stücke Blätterteig, in der Größe der Meerbarben
1 Eigelb
1 Tüte Sepia-Tinte
2 Auberginen
4 EL Olivenöl
2 Knoblauchzehen
2 Zweige Thymian
Zitronensaft, Salz, Pfeffer
8 Baby-Mozzarella, in Scheiben
8 Kirschtomaten, in Scheiben
4 TL Pesto
4 EL Kresse

Die Blätterteigstücke mit einer Mischung aus Eigelb und Sepia bestreichen und bei 180 °C ca. 8 Minuten backen. Beiseite stellen.
Die Auberginen halbieren, mit Salz bestreuen und Wasser ziehen lassen. In Olivenöl mit Knoblauch und Thymian von allen Seiten anbraten. Bei 180 °C im Ofen weich garen. Das weiche Innere aus der Schale kratzen und mit Zitronensaft, Salz und Pfeffer abschmecken.

Die Meerbarbenfilets würzen, auf der Hautseite knusprig anbraten und warm stellen.
Die Blätterteigstücke auf vier Teller setzen, mit Tomatenscheiben belegen, mit Pesto bestreichen, das Auberginenpüree darauf geben, die Mozzarellascheiben auf das Auberginenpüree legen, würzen und mit Kresse bestreuen. Jeweils ein Meerbarbenfilet auflegen und den Teller mit Kräutern und Essig garnieren.

4 filets de rouget de 120 g chacun
4 morceaux de pâte feuilletée de la taille des rougets
1 jaune d'œuf
1 sachet d'encre sépia
2 aubergines
4 c. à soupe d'huile d'olive
2 gousses d'ail
2 brins de thym
Jus de citron, sel, poivre
8 petites mozzarellas en tranches
8 tomates cerises en tranches
4 c. à café de pesto
4 c. à soupe de cresson

Badigeonner les morceaux de pâte feuilletée d'un mélange de jaune d'œuf et d'encre sépia et les cuire au four à 180 °C env. 8 minutes. Réserver. Couper les aubergines en deux, saupoudrer de sel et laisser dégorger puis faire revenir sur tous les côtés dans l'huile d'olive avec l'ail et le thym. Faire cuir à cœur au four à 180 °C. Retirer la chair cuite en raclant la peau et assaisonner au jus de citron, sel et poivre.

Assaisonner les filets de rouget, les saisir pour faire croustiller la peau et garder au chaud. Dresser les morceaux de pâte feuilletée sur quatre assiettes, garnir de tranches de tomate, tartiner de pesto, répartir dessus la purée d'aubergines, déposer les tranches de mozzarella sur la purée d'aubergine, assaisonner et décorer de cresson. Disposer respectivement un filet de rouget et garnir les assiettes d'herbes et de vinaigre.

4 filetes de salmonete de 120 g cada uno
4 trozos de masa de hojaldre del tamaño de los salmonetes
1 yema de huevo
1 sobre de tinta de sepia
2 berenjenas
4 cucharadas de aceite de oliva
2 dientes de ajo
2 ramas de tomillo
Zumo de limón, sal y pimienta
8 mini mozzarellas en rodajas
8 tomates cereza en rodajas
4 cucharaditas de pesto
4 cucharadas de berros

Untar los trozos de masa de hojaldre con una mezcla de yema de huevo y sepia y cocerlos al horno a 180 °C durante 8 minutos aprox. Reservarlos. Cortar las berenjenas por la mitad, rociarlas con sal y dejar que suelten el agua. Rehogarlas en aceite de oliva con ajo y tomillo por ambas caras. Hacerlas al horno a 180 °C hasta que queden blandas. Vaciar el interior blando y sazonarlo con zumo de limón, sal y pimienta.

Sazonar los salmonetes, freírlos por el lado de la piel hasta que ésta esté crujiente y reservarlos en caliente. Colocar los trozos de masa de hojaldre sobre cuatro platos, cubrirlos con las rodajas de tomate, untarlos de pesto, añadir el puré de berenjena, disponer encima del puré las rodajas de mozzarella, sazonar y decorar con berros. Colocar respectivamente un filete de salmonete y decorar el plato con hierbas frescas y vinagre.

4 filetti di triglia di 120 g ciascuno
4 pezzi di pasta sfoglia delle dimensioni delle triglie
1 tuorlo d'uovo
1 sacchetto di nero di seppia
2 melanzane
4 cucchiai di olio di oliva
2 spicchi d'aglio
2 rametti di timo
Succo di limone, sale, pepe
8 mozzarelline tagliate a fette
8 pomodorini tagliati a fette
4 cucchiaini di pesto
4 cucchiai di crescione

Spennellare i pezzi di pasta sfoglia con il tuorlo d'uovo e il nero di seppia e cuocerli in forno a 180 °C per circa 8 minuti. Metterli da parte. Dimezzare le melanzane, salarle, lasciarne uscire l'acqua e rosolarle nell'olio di oliva con l'aglio e il timo da tutti i lati. Cuocere quindi in forno a 180 °C. Estrarre la polpa dalla buccia e condirla con succo di limone, sale e pepe.

Condire i filetti di triglia, rosolarli dalla parte della pelle finché non saranno croccanti e teneri li in caldo. Disporre i pezzi di pasta sfoglia su quattro piatti, coprirli con le fette di pomodoro, cospargerli con il pesto e la purea di melanzane, ripartirvi sopra le fette di mozzarella, condire e cospargervi il crescione. Disporvi sopra un filetto di triglia e guarnire il piatto con le erbe e l'aceto.

Rib Room

Design: Design Division refurbished by LWDesign Group LLC
Owner: Jumeirah | Chef: Luigi Gerosa

Jumeirah Emirates Towers, Sheikh Zayed Road | Dubai
Phone: +971 4 319 8741
www.jumeirah.com
Opening hours: Every day lunch 12:30 pm to 3 pm, dinner 7:30 pm to midnight
Menu price: AED 240
Cuisine: Steak and seafood
Special features: Succulent steaks and freshest seafood in a relaxing, chic and stylish
setting; Wagyu beef; menu with the finest selection of rums on offer

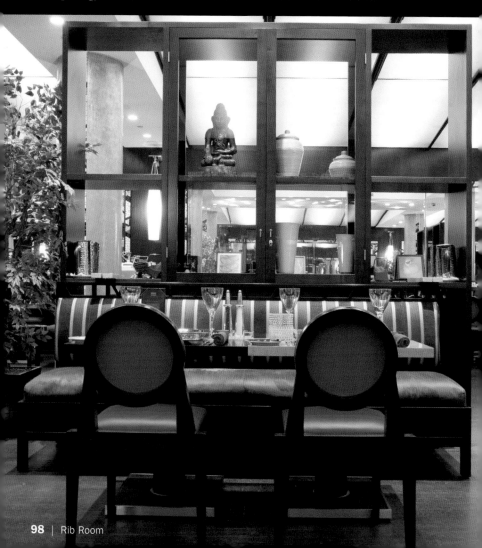

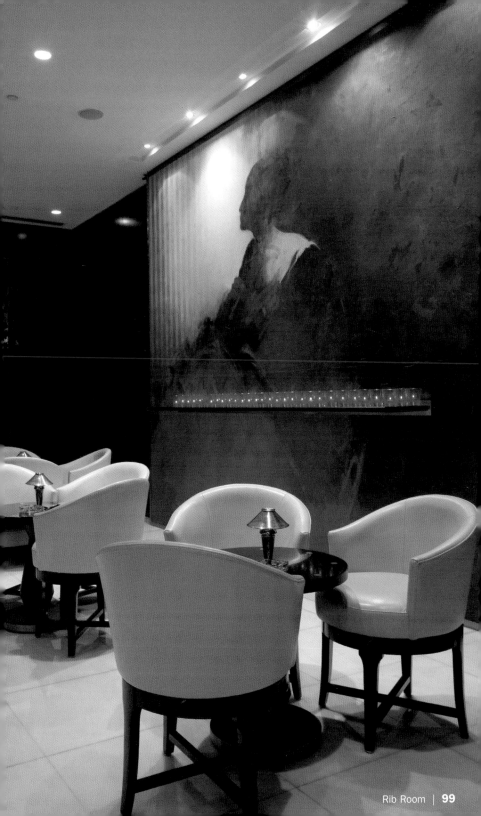

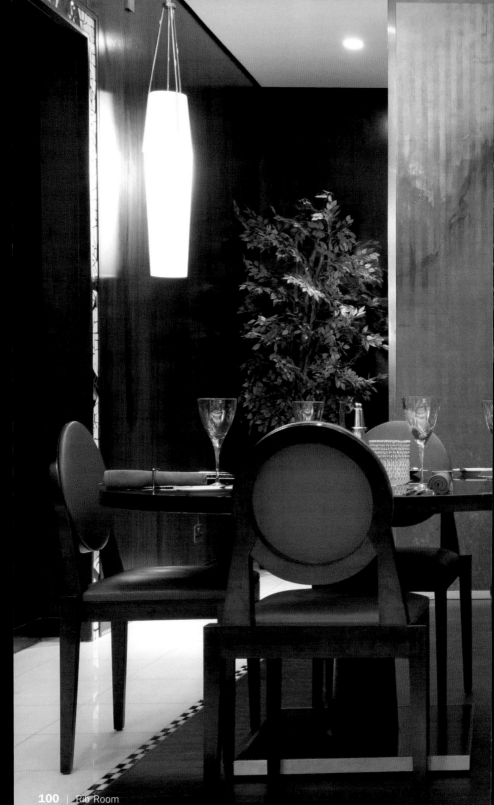

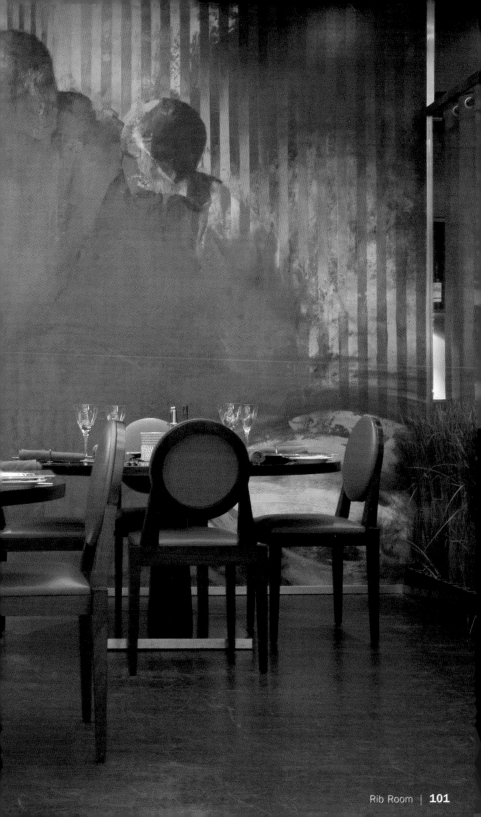

Beef Tenderloin
with Baked Vegetables

Rinderfilet mit gebackenem Gemüse
Filet de bœuf et ses légumes rôtis
Solomillo de vaca con verdura asada
Filetto di manzo con verdure al forno

4 pieces beef tenderloin, 11 oz each
Salt, pepper
4 tbsp vegetable oil
Season the beef tenderloin with salt and pepper and sear from both sides. Bake in an 480 °F oven to the desired doneness.

1 carrot, diced
3 1/2 oz celeriac, diced
1 onion, diced
3 tbsp vegetable oil
200 ml red wine
500 ml beef stock
Sear the vegetables until golden brown, deglaze with red wine, let the liquid evaporate and fill up with beef stock. Reduce to one third, strain and season.

2 potatoes, washed
2 tomatoes
4 small red bell peppers
2 tbsp olive oil
6 1/2 oz green beans
2 tbsp butter
Salt, pepper
Different herbs for decoration
Cut the potatoes in half and cook until soft. Season with salt and pepper and let them brown in an oven. Cut the tomatoes in half, season and roast for 7 minutes in the oven. Rub the bell peppers with olive oil and season and roast at 480 °F until the skin starts to brown and shows bubbles. Cut in half. Blanch the green beans and toss in hot butter. Season.
Divide the meat and the vegetables amongst four plates and drizzle with sauce.

4 Stücke Rinderfilet, à 320 g
Salz, Pfeffer
4 EL Pflanzenöl
Das Rinderfilet salzen und pfeffern und von beiden Seiten scharf anbraten. Bei 250 °C im Backofen bis zur gewünschten Garstufe braten.

1 Karotte, gewürfelt
100 g Knollensellerie, gewürfelt
1 Zwiebel, gewürfelt
3 EL Pflanzenöl
200 ml Rotwein
500 ml Rinderbrühe
Das Gemüse anrösten und mit Rotwein ablöschen, einreduzieren lassen und mit Rinderbrühe auffüllen. Bis zu einem Drittel einreduzieren lassen, passieren und abschmecken.

2 Kartoffeln, gewaschen
2 Tomaten
4 kleine rote Paprika
2 EL Olivenöl
200 g grüne Bohnen
2 EL Butter
Salz, Pfeffer
Diverse Kräuter zur Dekoration
Die Kartoffeln halbieren und weich kochen. Mit Salz und Pfeffer würzen und im Ofen bräunen. Die Tomaten halbieren, würzen und für 7 Minuten im Ofen rösten. Die Paprikaschoten mit Olivenöl einreiben und würzen und bei 250 °C so lange rösten, bis die Haut braun ist und Blasen wirft. Halbieren. Die grünen Bohnen blanchieren und in heißer Butter schwenken. Würzen.
Das Fleisch und die Gemüse auf vier Tellern verteilen und mit der Sauce beträufeln.

4 morceaux de filet de bœuf de 320 g chacun
Sel, poivre
4 c. à soupe d'huile végétale
Saler et poivrer le filet de bœuf et le saisir des
deux côtés à feu vif. Le cuire ensuite au four à
250 °C pour obtenir la cuisson désirée.

1 carotte en dés
100 g de céleri rave en dés
1 oignon en dés
3 c. à soupe d'huile végétale
200 ml de vin rouge
500 ml de bouillon de bœuf
Faire dorer les légumes et mouiller au vin rouge,
laisser réduire et compléter avec le bouillon de
bœuf. Faire réduire jusqu'à un tiers, passer au
chinois et rectifier l'assaisonnement.

2 pommes de terre lavées
2 tomates
4 petits poivrons rouges
2 c. à soupe d'huile d'olive
200 g de haricots verts
2 c. à soupe de beurre
Sel, poivre
Herbes variées pour la décoration
Couper les pommes de terre en deux et les faire
cuire complètement. Saler, poivrer et les faire dorer
au four. Couper les tomates en deux, les assaison-
ner et les griller 7 minutes au four. Badigeonner les
poivrons d'huile, assaisonner et les griller à 250 °C
jusqu'à ce que la peau soit noircie et boursouflée.
Les couper en deux. Blanchir les haricots et les
poêler dans le beurre chaud. Assaisonner.
Répartir la viande et les légumes sur quatre assiet-
tes et arroser de sauce.

4 trozos de solomillo de vaca de 320 g cada
uno
Sal, pimienta
4 cucharadas de aceite vegetal
Salpimentar la carne y freírla a fuego fuerte por
ambos lados. Asarla al horno a 250 °C hasta
que esté al punto deseado.

1 zanahoria picada
100 g de apio nabo picado
1 cebolla picada
3 cucharadas de aceite vegetal
200 ml de vino tinto
500 ml de caldo de carne
Sofreír la verdura y rociarla con vino tinto,
reducirla y cubrirla con el caldo de carne. Dejar
reducir hasta un tercio, tamizar y sazonar.

2 patatas lavadas
2 tomates
4 pimientos rojos pequeños
2 cucharadas de aceite de oliva
200 g de judías verdes
2 cucharadas de mantequilla
Sal, pimienta
Hierbas frescas para decorar
Cortar por la mitad las patatas y cocerlas hasta
que estén blandas. Salpimentarlas y dorarlas en
el horno. Cortar por la mitad los tomates, sazo-
narlos y dorarlos en el horno durante 7 minutos.
Untar los pimientos con aceite de oliva, sazonar-
los y asarlos en el horno a 250 °C hasta que la
piel esté dorada y tenga ampollas. Cortarlos por
la mitad. Blanquear las judías verdes y saltearlas
en mantequilla caliente. Sazonarlas.
Distribuir la carne y la verdura en cuatro platos y
rociar con la salsa.

4 pezzi di filetto di manzo di 320 g ciascuno
Sale, pepe
4 cucchiai di olio vegetale
Salare e pepare i filetti di manzo e rosolarli a
fuoco vivo da entrambi i lati. Proseguire la cottu-
ra in forno a 250 °C fino al punto desiderato.

1 carota tagliata a dadini
100 g di sedano rapa tagliato a dadini
1 cipolla tagliata a dadini
3 cucchiai di olio vegetale
200 ml di vino rosso
500 ml di brodo di manzo
Rosolare le verdure e bagnarle con il vino rosso,
far restringere e versare il brodo di manzo. Far
restringere ancora fino a un terzo, passare al pas-
saverdura, assaggiare e regolare il condimento.

2 patate lavate
2 pomodori
4 piccoli peperoni rossi
2 cucchiai di olio di oliva
200 g di fagiolini verde
2 cucchiai di burro
Sale, pepe
Erbe varie per la guarnizione
Tagliare a metà le patate e cuocerle finché siano
tenere. Salarle, peparle e dorarle in forno. Tagliare
a metà i pomodori, condirli e arrostirli in forno per 7
minuti. Strofinare i peperoni con olio di oliva, condir-
li e arrostirli a 250 °C finché la pelle diventa marro-
ne e si formano delle bollicine. Dimezzarli. Scottare
i fagiolini e saltarli nel burro caldo. Condirli.
Ripartire la carne e le verdure in quattro piatti e
pillottarle con la salsa.

Rodeo Grill and Bar

Design: wa international | Owner: Al Bustan Rotana Hotel
Chef: Anil Dodani

Casablanca Road, Al Garhoud Area | Dubai
Phone: +971 7 705 4620
www.rotana.com
Opening hours: Every day lunch noon to 3 pm, dinner 7 pm to midnight
Menu price: AED 250
Cuisine: Steakhouse

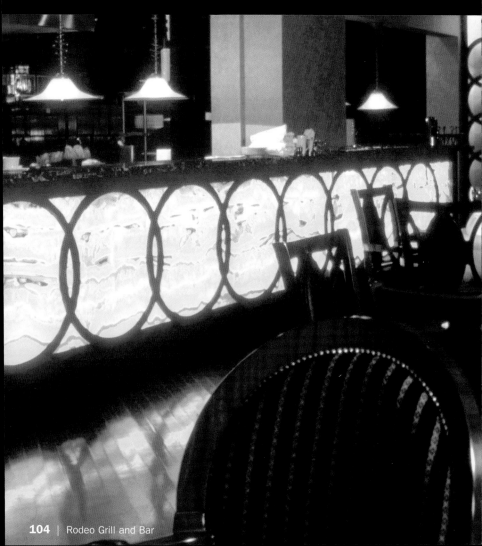

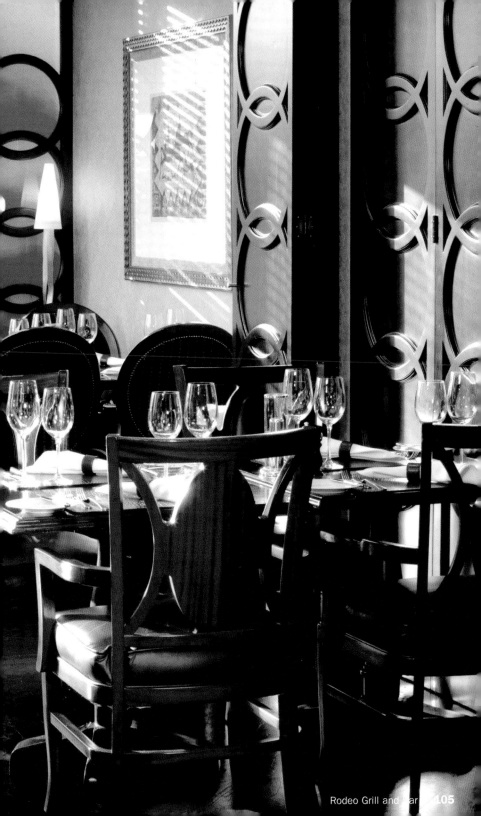

Segreto

Design: Khuan Chew of KCA International | Owner: Jumeirah
Chef: Heiko Schreiner

Madinat Jumeirah, Al Sufouh Road | Dubai
Phone: +971 4 366 6125
www.jumeirah.com
Opening hours: Every day lunch noon to 3 pm, dinner 7 pm to 11:30 am
Menu price: AED 240
Cuisine: Italian

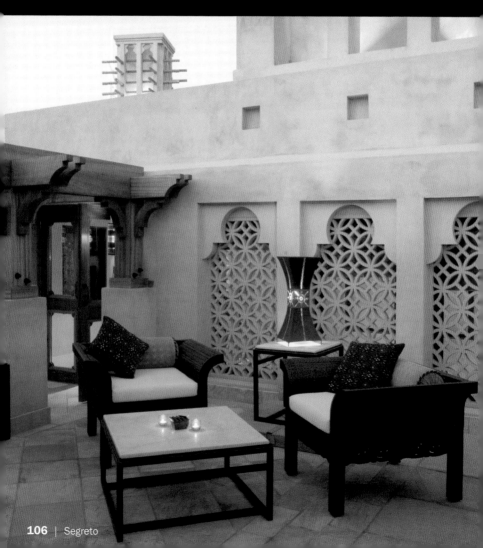

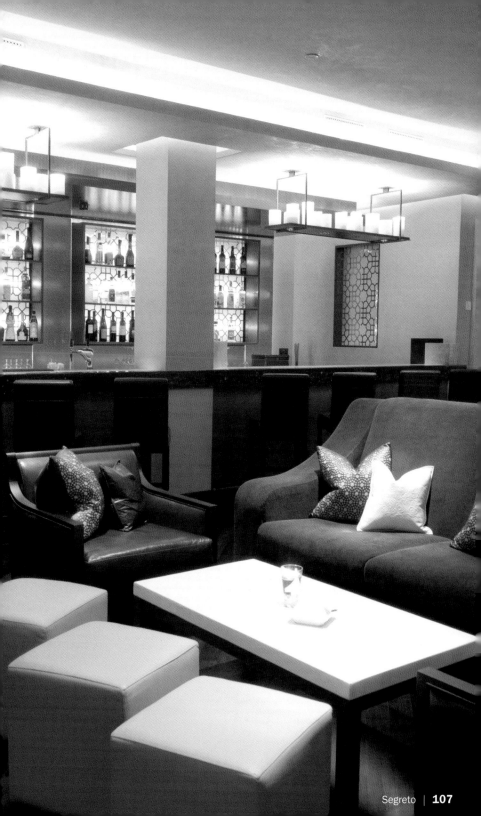

Shang Palace

Design: Bilkey Llinas | Owner: Obeid Al Jaber
Chef: Ken Huang

Shangri-La Hotel, Dubai, Sheikh Zayed Road | Dubai
Phone: +971 4 343 8888
www.shangri-la.com
Opening hours: Every day lunch 12:30 pm to 3 pm, dinner 8 pm to midnight
Menu price: AED 75
Cuisine: Cantonese
Special features: Cantonese specialties

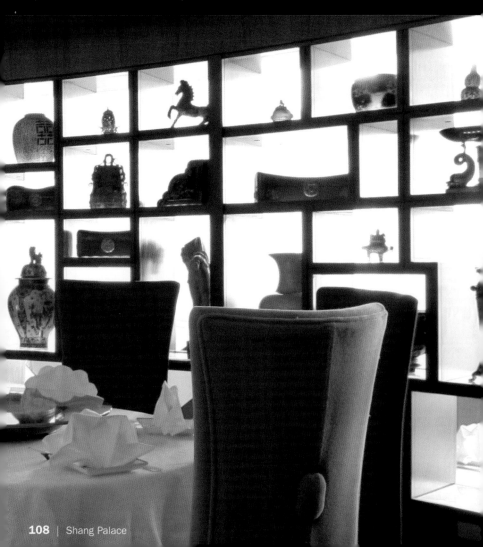

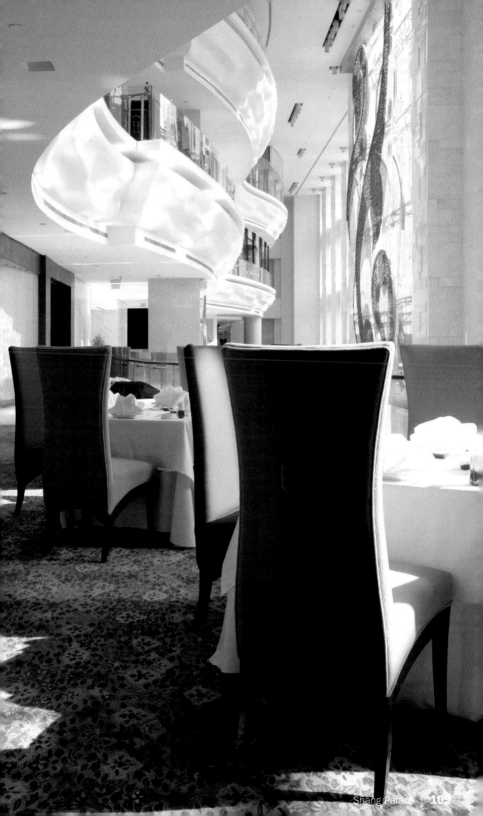

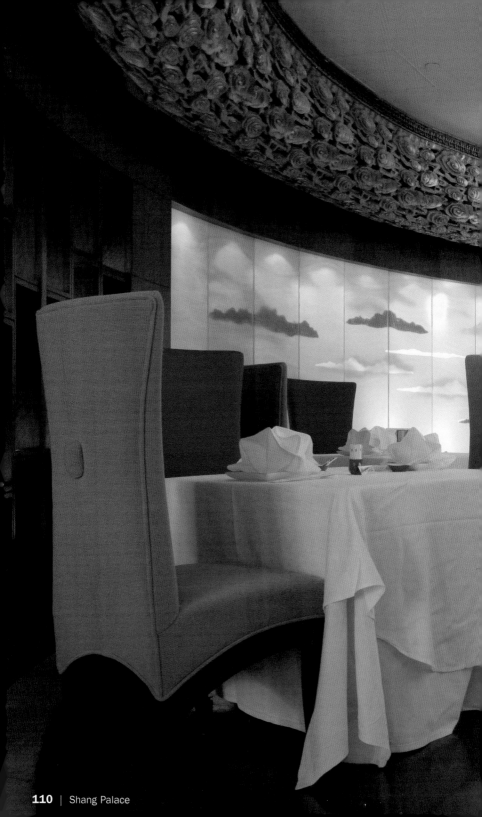

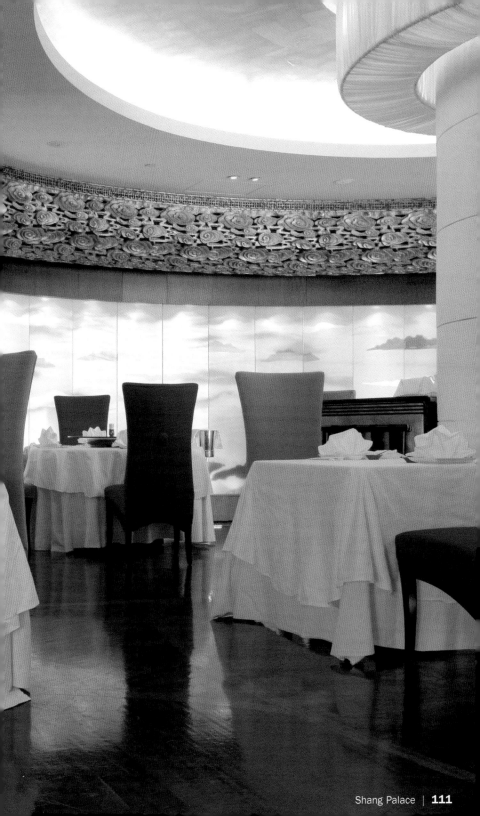

Shoo Fee Maa Fee

Design: Khuan Chew of KCA International | Owner: Jumeirah
Chef: Heiko Schreiner

Madinat Jumeirah-Souk | Dubai
Phone: +971 4 366 6335
www.jumeirah.com
Opening hours: Every day dinner 7 pm to 0:30 am
Menu price: AED 120
Cuisine: Modern Moroccan with international twist, Lebanese
Special features: Rooftop terraces

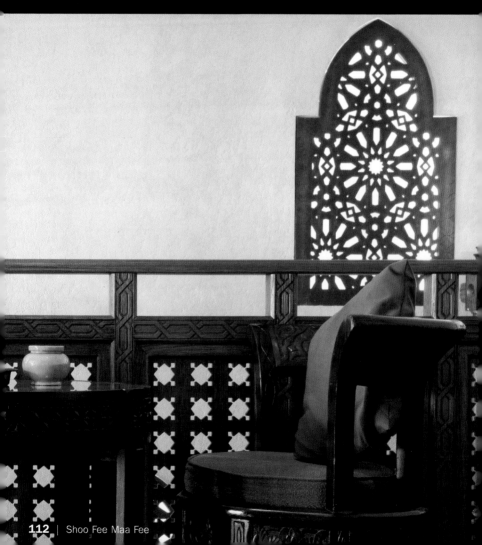

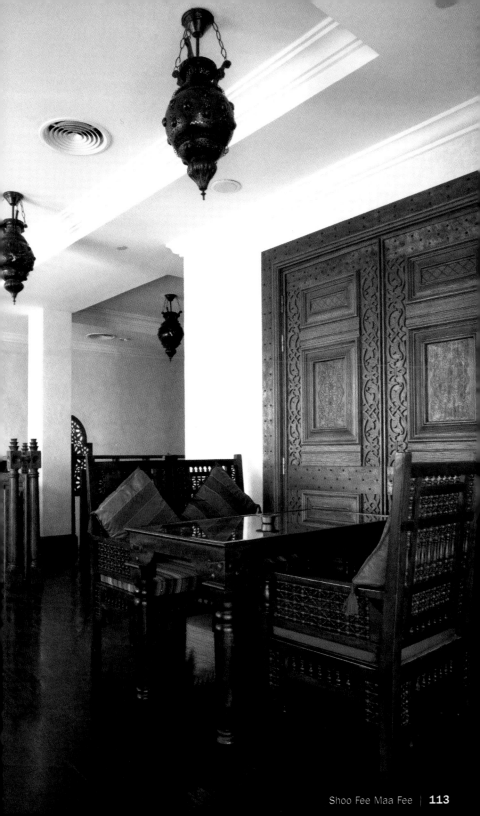

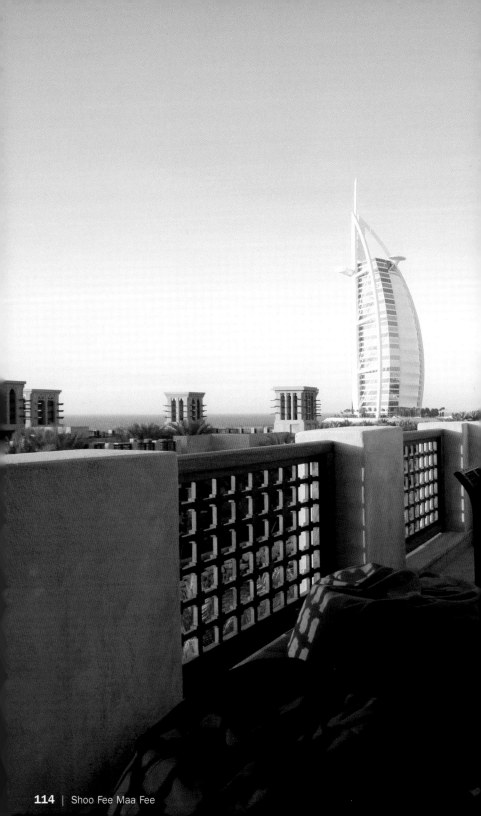

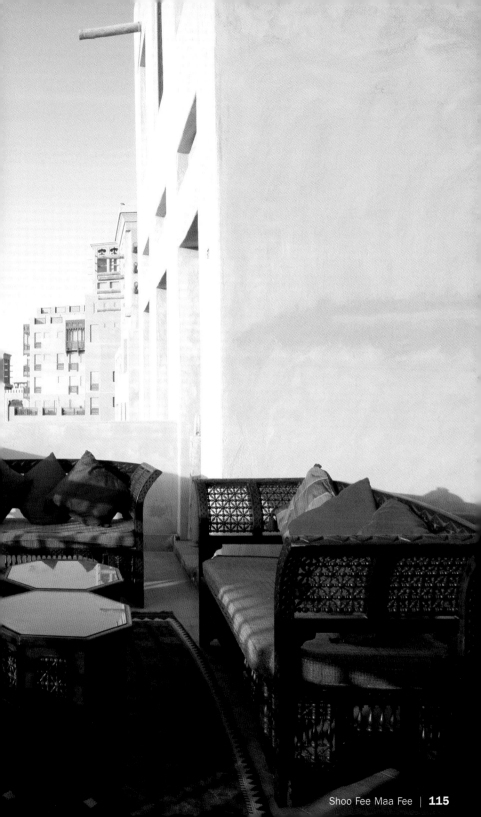

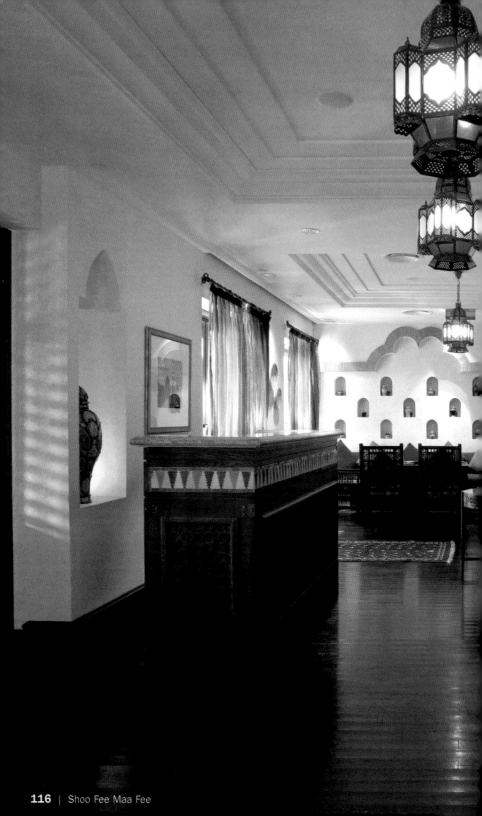

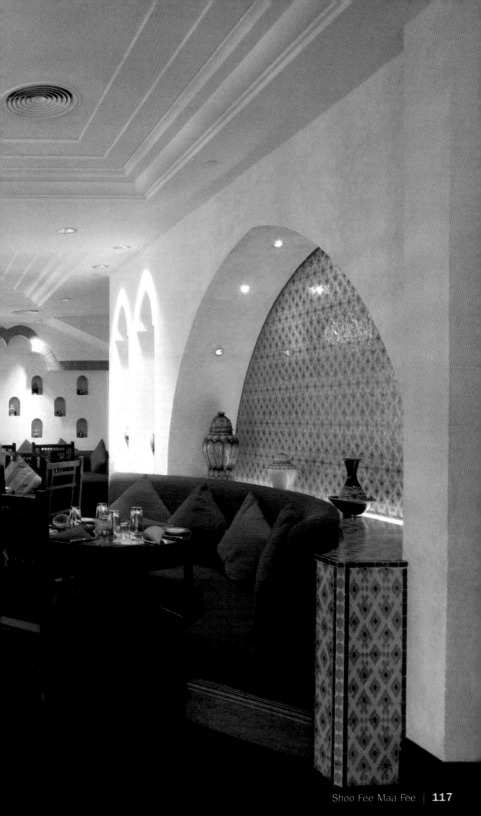

Tokyo@the Towers

Design: Design Division | Owner: Jumeirah | Chef: Luigi Gerosa

Shopping Boulevard, Jumeirah Office Tower, Sheikh Zayed Road | Dubai
Phone: +971 4 319 8793
www.jumeirah.com
Opening hours: Every day lunch 12:30 pm to 3 pm, dinner 8:30 pm to midnight
Menu price: AED 85
Cuisine: Traditional Japanese
Special features: Teppanyaki tables with live cooking by your own entertaining chef;
intimate private Tatami rooms set amongst a pillar-lined gallery, Sushi bar.

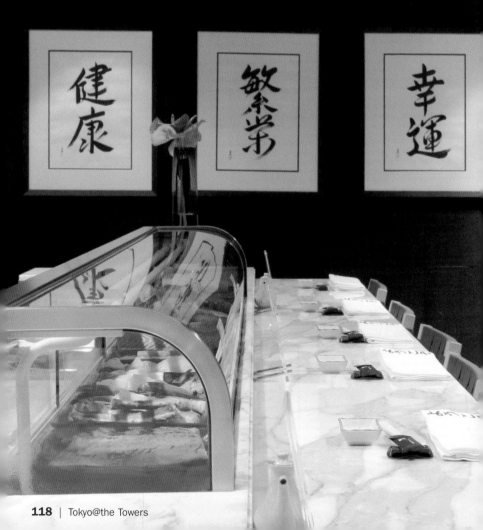

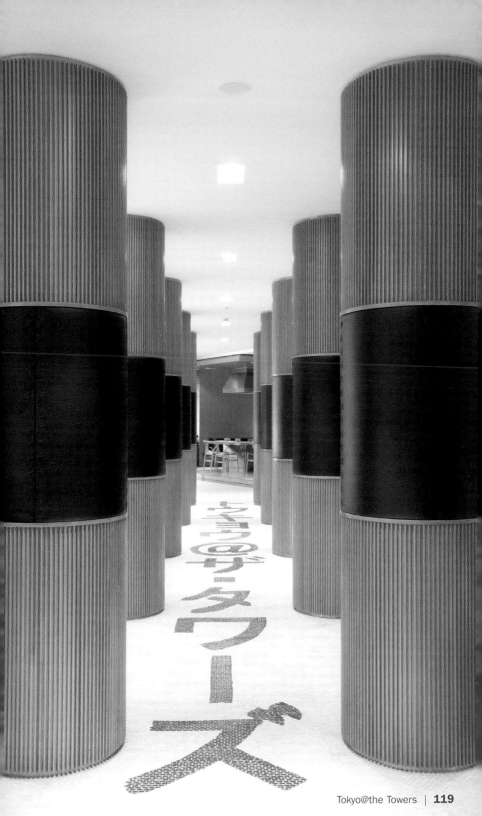

東京のデータワーズ

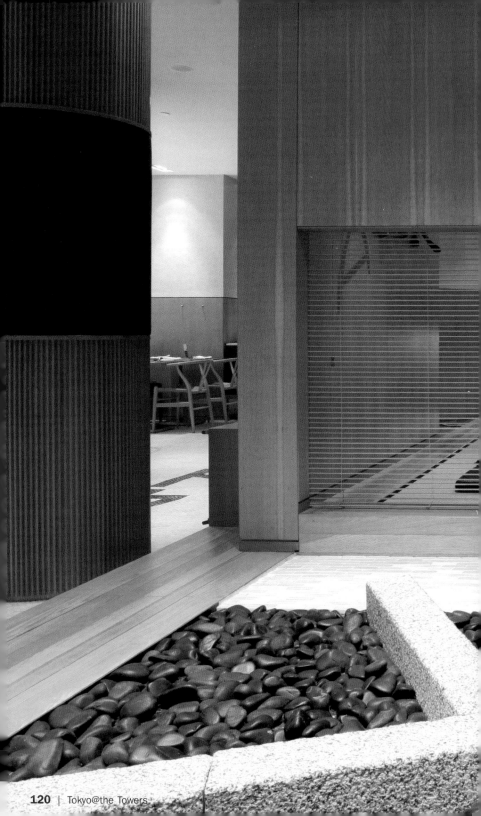

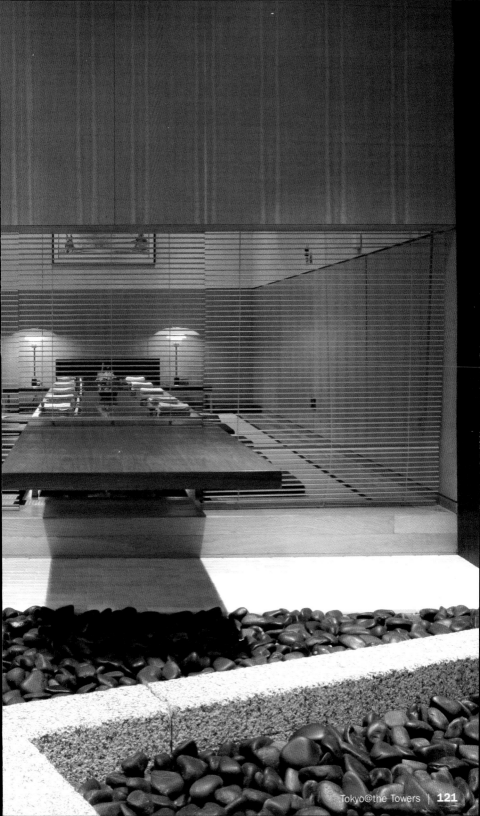

OMAKASE

10 oz sushi-rice
600 ml water
Wash the rice several times, drain and cook with
600 ml water until soft.

60 ml rice vinegar
1 oz sugar
1 tsp salt
Combine all ingredients and bring to a boil.
Combine rice and marinade.

24 pieces fish and seafood, (e. g. salmon, tuna,
tobiko, king prawn, hiramasa) 1 oz each
Wasabi, pickled and fresh ginger for decoration

Shape approx. 1 tbsp rice to a roll and top with
a piece of fish. Chill immediately and shape the
other sushi parts.

Arrange 6 pieces sushi on a long plate and
serve with wasabi and ginger.

300 g Sushi-Reis
600 ml Wasser
Den Reis mehrmals waschen, abtropfen lassen
und mit 600 ml Wasser gar kochen.

60 ml Reisessig
30 g Zucker
1 TL Salz
Alle Zutaten mischen und aufkochen. Reis und
Marinade mischen.

24 Stücke Fisch und Meeresfrüchte, (z. B. Lachs,
Tunfisch, Tobiko, Königskrabbe, Hiramasa) à 30 g
Wasabi, eingelegter und frischer Ingwer zur
Dekoration

Ca. 1 EL Reis in der Hand zu einer länglichen
Rolle formen und ein Fischstück darauf legen.
Sofort kalt stellen und die restlichen Sushi-
Stücke formen.

Jeweils 6 Teile auf vier länglichen Tellern ver-
teilen und mit Wasabi und Ingwer servieren.

300 g de riz pour sushi
600 ml d'eau
Laver plusieurs fois le riz, l'égoutter et le cuire
complètement dans 600 ml d'eau.

60 ml de vinaigre de riz
30 g de sucre
1 c. à café de sel
Mélanger les ingrédients et les amener à ébulli-
tion. Mélanger le riz et la marinade.

24 morceaux de poisson et de fruits de mer (par
ex. saumon, thon, crabe royal, hiramasa) de 30 g
chacun
Wasabi, gingembre mariné et frais pour la décoration

Avec env. 1 c. à soupe de riz, former dans la
main un rouleau oblong et poser un morceau de
poisson dessus. Mettre tout de suite au frais et
former les autres morceaux de sushi.

Dresser respectivement 6 morceaux sur quatre
assiettes oblongues et servir avec du wasabi et
du gingembre.

300 g de arroz para Sushi
600 ml de agua
Lavar el arroz varias veces, escurrirlo y cocerlo
en 600 ml de agua.

60 ml de vinagre de arroz
30 g de azúcar
1 cucharadita de sal
Mezclar todos los ingredientes y cocerlos. Mez-
clar el arroz con la marinada.

24 trozos de pescado y marisco (p.ej. salmón,
bonito, tobiko, cangrejo real, hiramasa) de 30 g
cada uno
Wasabi y jengibre fresco marinado para decorar

Colocar 1 cucharada de arroz en la mano, formar
una bolita, encima un trozo de pescado y apretar
hasta que quede alargada. Reservar inmediata-
mente en un lugar frío y formar el resto de los
pedazos de sushi.

Colocar 6 pedazos en cuatro platos respectiva-
mente y servirlos con wasabi y jengibre.

300 g di riso sushi
600 ml d'acqua
Lavare più volte il riso, scolarlo e cuocerlo in
600 ml d'acqua.

60 ml di aceto di riso
30 g di zucchero
1 cucchiaino di sale
Mescolare tutti gli ingredienti e portarli a cottura.
Mescolare il riso e la marinata.

24 tranci di pesce e frutti di mare (ad es. salmo-
ne, tonno, tobiko, gambero reale, hiramasa) di
30 g ciascuno
Wasabi, zenzero fresco e in conserva per la
guarnizione

Prendere circa 1 cucchiaio di riso e formare con
le mani un rotolo allungato. Porvi sopra un pez-
zetto di pesce. Mettere subito in frigo e preparare
le altre porzioni di sushi.

Disporre porzioni di 6 rotoli ciascuna in piatti
di forma allungata e servire con il wasabi e lo
zenzero.

Traiteur

Design: Wilson & Associates | Owner: Park Hyatt Dubai
Chef: Massimiliano Valenzi

Park Hyatt Dubai, Dubai Creek Golf & Yacht Club | Dubai
Phone: + 971 4 602 1234
www.dubai.park.hyatt.com
Opening hours: Every day lunch 12:30 pm to 3:30 pm, dinner 7 pm to midnight
Menu price: 250 AED
Cuisine: Modern European
Special features: Cave Privée, a 4,200-bottle wine cellar with dining area, plus one
additional private dining room, seating up to 14 people

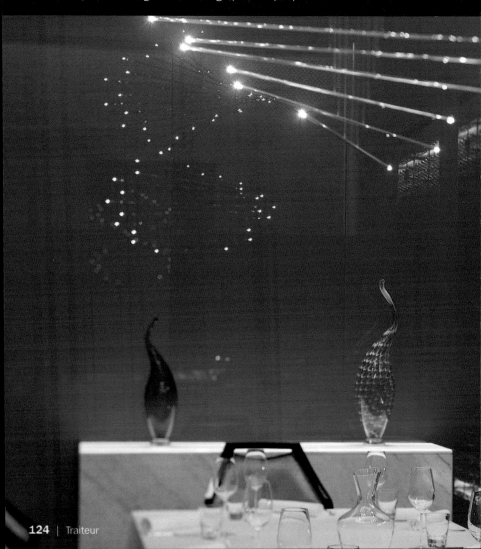

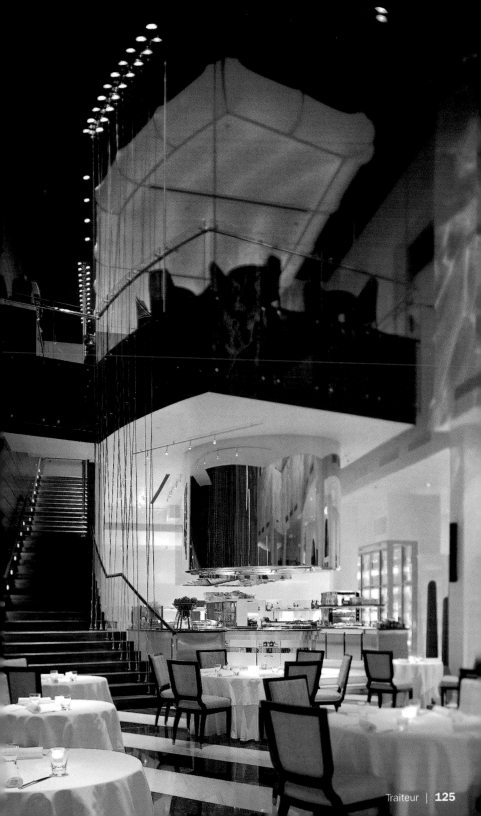

Vu's

Design: Design Division | Owner: Jumeirah | Chef: Luigi Gerosa

Jumeirah Emirates Towers, Sheikh Zayed Road | Dubai
Phone: +971 4 319 8771
www.jumeirah.com
Opening hours: Every day lunch 12:30 pm to 3 pm, dinner 7:30 pm to midnight
Menu price: AED 155–385
Cuisine: Modern European with Asian flavors
Special features: Beautiful views from level 50

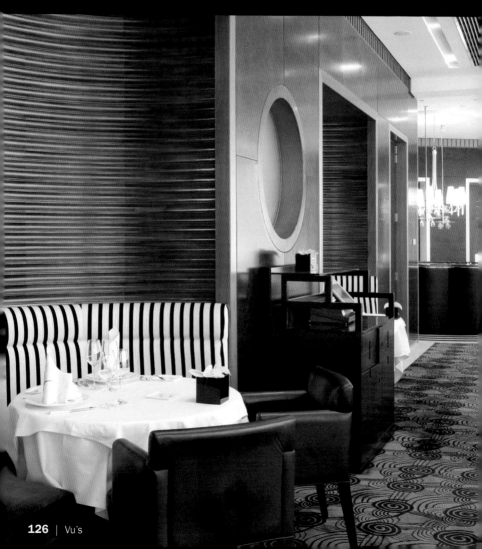

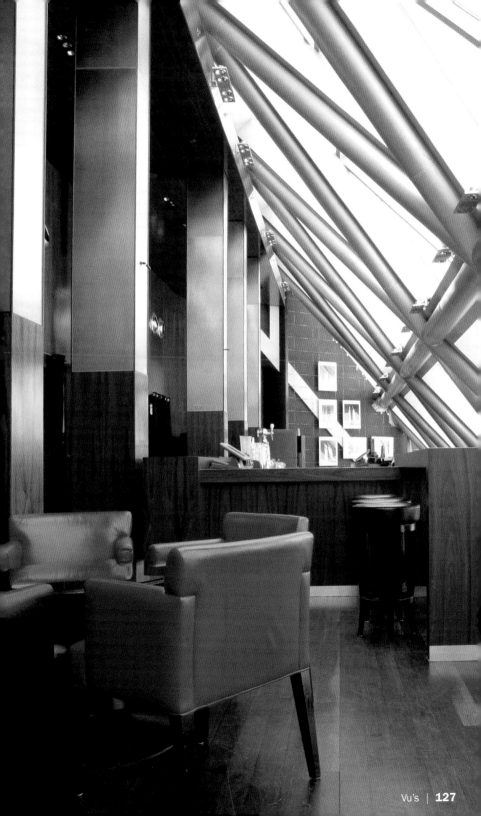

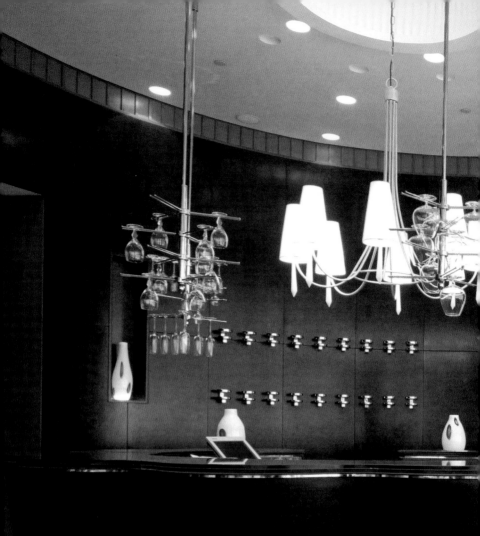

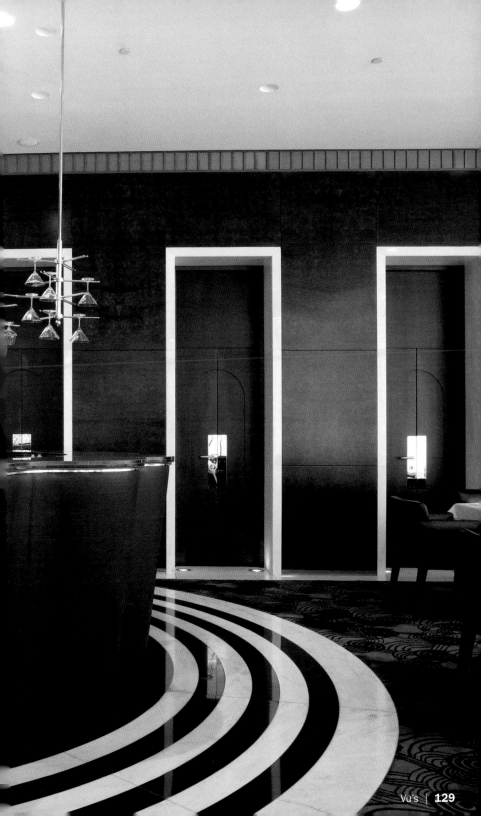

Zheng He's

Design: Khuan Chew of KCA International | Owner: Jumeirah
Chef: Heiko Schreiner

Madinat Jumeirah – Mina A' Salam | Dubai
Phone: +971 4 366 6159
www.jumeirah.com
Opening hours: Every day lunch noon to 3 pm, dinner 7 pm to 11:30 pm
Menu price: AED 250
Cuisine: Modern Chinese
Special features: Terrace

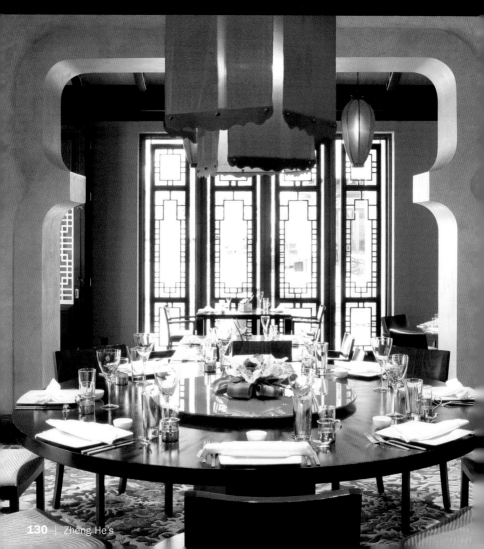

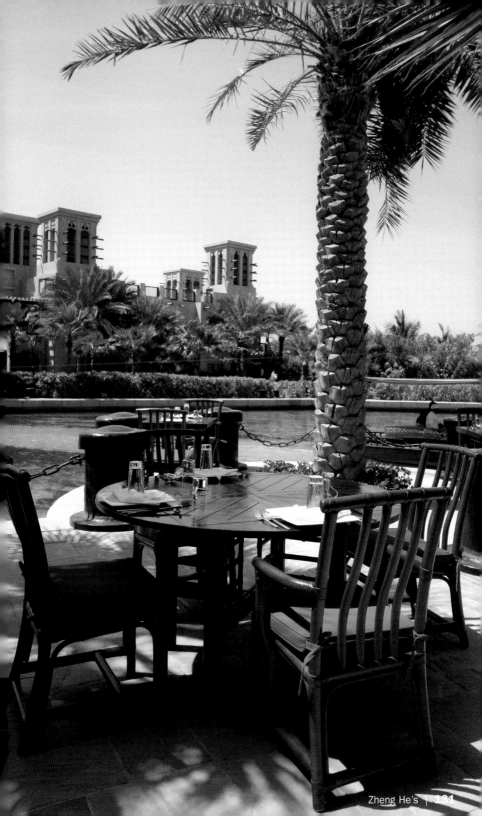

Wasabi Prawns
with Mango Salsa

Wasabi-Garnelen mit Mango Salsa
Crevettes au wasabi avec sauce à la mangue
Gambas al wasabi con salsa de mango
Gamberi al wasabi con salsa al mango

20 large prawns, cleaned
Salt, pepper
3 tbsp corn starch
Oil for deep-frying
5 tbsp wasabi-mayonnaise (Blair's Wasabi Ginger Sauce)

1 mango, diced finely
1 red chili, diced
Salt, pepper, sugar
2 tbsp fruit vinegar
Frisée lettuce and cress for decoration

Combine the diced mango with the chili and season with the other ingredients.
Season the prawns and toss in corn starch.
Deep-fry at 320 °F for approx. 4 minutes, drain on kitchen paper and coat with wasabi-mayonnaise while still hot.
Spread the frisée lettuce amongst four plates, arrange the wasabi-prawns on top of the lettuce, garnish with mango salsa and cress and serve immediately.

20 große Garnelen, geputzt
Salz, Pfeffer
3 EL Stärke
Öl zum Frittieren
5 EL Wasabi-Mayonnaise (Blair's Wasabi Ginger Sauce)

1 Mango, klein gewürfelt
1 rote Chili, gewürfelt
Salz, Pfeffer, Zucker
2 EL Obstessig
Friséesalat und Kresse zur Dekoration

Die Mangowürfel mit der Chili mischen und mit den restlichen Zutaten abschmecken.
Die Garnelen würzen und in der Stärke wälzen.
Bei 160 °C ca. 4 Minuten frittieren, abtropfen lassen und noch heiß mit der Wasabi-Mayonnaise mischen.
Friséesalat auf vier Tellern verteilen, die Wasabi-Garnelen auf dem Salat arrangieren, mit Mango-Salsa und Kresse garnieren und sofort servieren.

20 grosses crevettes décortiquées
Sel, poivre
3 c. à soupe de fécule
Huile pour la friture
5 c. à soupe de mayonnaise au wasabi (Blair's Wasabi Ginger Sauce)

1 mangue en petits dés
1 piment rouge en dés
Sel, poivre, sucre
2 c. à soupe de vinaigre
Salade frisée et cresson pour la décoration

Mélanger les dés de mangue avec le piment et assaisonner avec le reste des ingrédients.
Assaisonner les crevettes et les rouler dans la fécule. Les faire frire à 160 °C env. 4 minutes, les égoutter et les mélanger encore chaudes à la mayonnaise au wasabi.
Répartir la salade frisée sur quatre assiettes, dresser les crevettes au wasabi sur la salade, garnir de sauce à la mangue et décorer avec du cresson. Servir de suite.

20 gambas grandes limpias
Sal, pimienta
3 cucharadas de fécula
Aceite para freír
5 cucharadas de mahonesa de wasabi (Blair's Wasabi Ginger Sauce)

1 mango cortado en daditos
1 chile rojo picado
Sal, pimienta, azúcar
2 cucharadas de vinagre de fruta
Escarola y berros para decorar

Mezclar los daditos de mango con el chile y sazonarlos con el resto de los ingredientes.
Salpimentar las gambas y rebozarlas con la fécula, freírlas a 160 °C durante 4 minutos aprox. Escurrir la grasa y mezclarlas con la mahonesa de wasabi.
Repartir la escarola en cuatro platos, colocar las gambas al wasabi sobre la escarola, rociarlas con la salsa de mango y berros y servirlas al instante.

20 gamberi puliti
Sale, pepe
3 cucchiai di amido
Olio per friggere
5 cucchiai di maionese al wasabi (Blair's Wasabi Ginger Sauce)

1 mango tagliato a dadini piccoli
1 peperoncino rosso tagliato a dadini
Sale, pepe, zucchero
2 cucchiai di aceto di frutta
Insalata riccia e crescione per la guarnizione

Mescolare i dadini di mango con il peperoncino e condirli gli altri ingredienti.
Condire i gamberi e passarli nell'amido. Friggerli a 160 °C per circa 4 minuti, sgocciolarli e mescolarli ancora caldi con la maionese al wasabi. Ripartire in quattro piatti l'insalata riccia, disporvi sopra i gamberi al wasabi e guarnire con la salsa al mango e il crescione. Servire subito.

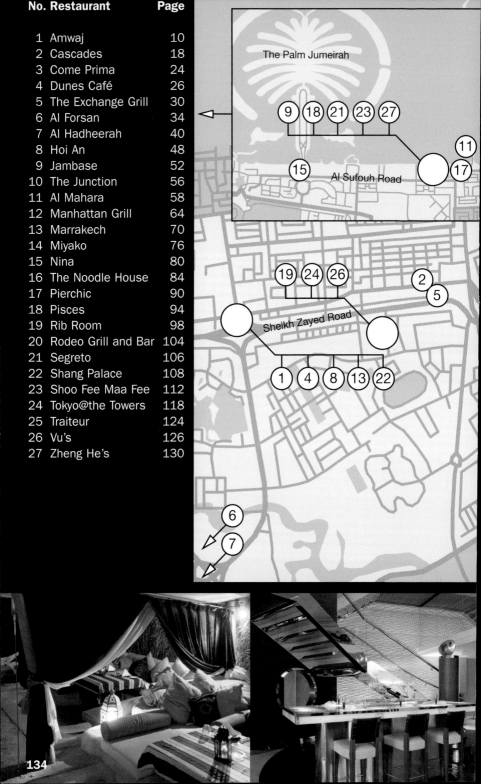

The Palm Jumeirah

Al Sufouh Road

Sheikh Zayed Road

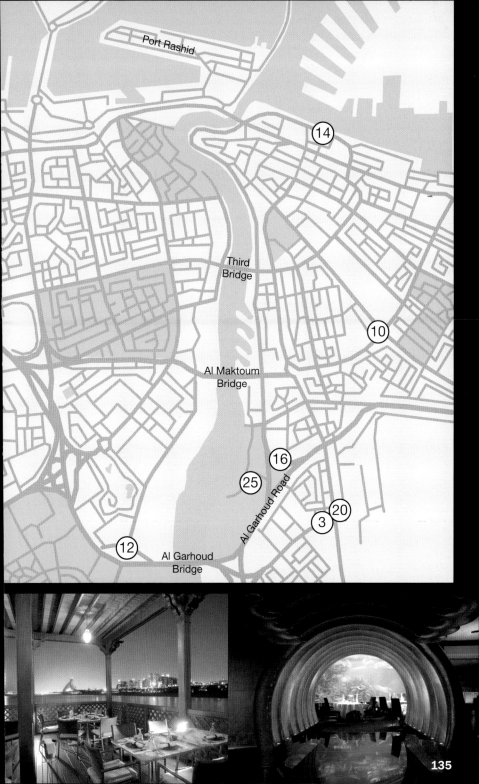

Port Rashid

14

Third
Bridge

10

Al Maktoum
Bridge

16

25

Al Garhoud Road

3 20

12

Al Garhoud
Bridge

Cool Restaurants

COOL SHOPS

COOL SPOTS

Size: 14 x 21.5 cm
5 1/2 x 8 1/2 in.
136 pp, Flexicover
c. 130 color photographs
Text in English, German,
French, Spanish, Italian
or (*) Dutch

teNeues